FIRST MEAL

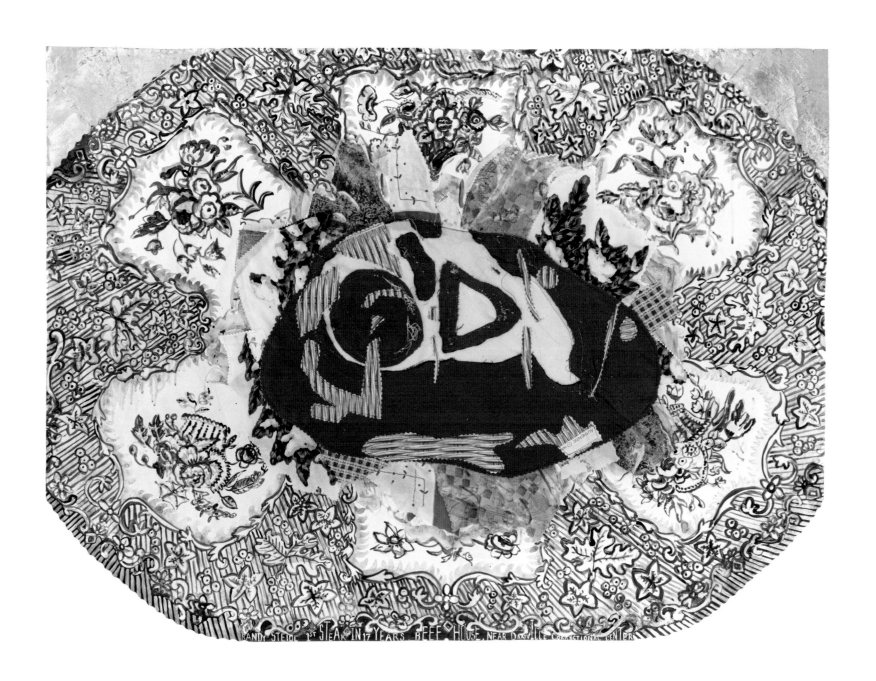

FIRST MEAL

Julie Green and Kirk Johnson

OREGON STATE UNIVERSITY PRESS CORVALLIS

This book was published in conjunction with the exhibition, "Thank God, I'm Home: First Meals by Julie Green," held at the Harold B. Lemmerman Gallery, New Jersey City University, from February 2 to March 25, 2022. This publication was made possible in part from the Ford Family Foundation grant.

Library of Congress Cataloging-in-Publication Data
Names: Green, Julie, 1961-1921, author. | Johnson, Kirk, 1958- author.
Title: First meal / Julie Green and Kirk Johnson.
Description: Corvallis : Oregon State University Press, [2023] | Includes bibliographical references.
Identifiers: LCCN 2023026155 | ISBN 9780870712456 (hardcover)
Subjects: LCSH: Judicial error—United States. | Criminal justice, Administration—United States.
Classification: LCC HV7419.3 .G74 2023 | DDC 364/.042—dc23/ eng/20230706
LC record available at https://lccn.loc.gov/2023026155

First published in 2023 by Oregon State University Press
Printed in South Korea

Oregon State University Press
121 The Valley Library
Corvallis OR 97331-4501
541-737-3166 · fax 541-737-3170
www.osupress.oregonstate.edu

Oregon State University Press in Corvallis, Oregon, is located within the traditional homelands of the Mary's River or Ampinefu Band of Kalapuya. Following the Willamette Valley Treaty of 1855, Kalapuya people were forcibly removed to reservations in Western Oregon. Today, living descendants of these people are a part of the Confederated Tribes of Grand Ronde Community of Oregon (grandronde.org) and the Confederated Tribes of the Siletz Indians (ctsi.nsn.us).

Contents

Introduction

Imagine for a moment that you've been incarcerated, perhaps for decades, for a crime you didn't commit. You've seen your life, and whatever dreams and possibilities it might have once contained, stolen from you—swallowed up inside a criminal justice system that failed to deliver anything resembling justice. You may have lost hope and come to doubt that anything could ever be righted.

But then it happens: after years of appeals and investigations, you're exonerated and freed to step out into the world. What do you want to do with the rest of your life? How do you make the most of the years you have left? Before you make your larger plans, however, another seemingly small question arises. It grumbles up, full of all the implications of being a free human being.

What do you want to eat?

After having unfairly endured a world with few options—when to sleep and when and what to eat, all dictated by the clanking schedule of a corrections system—a door of choice has opened. What is the first meal of a new life?

This was the first inspiration for the book you hold in your hands—that looking through the opened door of choice at such a transformative moment would reveal something about humanity and the American system of justice.

Choice is such a simple concept, taken for granted by most of us most of the time, while at the same time immeasurably deep. Choice is liberation and risk, spontaneity and calculation, and it hinges, always, on a split moment in time. Making choices demands that we reach back through our own personal histories to determine what is important, and also look forward into the future, with the understanding that every choice is also a building block for choices yet to come.

When a person is improperly and unjustly denied choice, they've had more taken from them than just their freedom. And so when they finally can choose, it is also more than just a choice—even when the decisions to be made can appear routine and mundane. Each first meal is invariably a declaration—quiet and contemplative for some, loud and exuberant for others, but anchored for all in the astonishing power of being able to do it at all.

Sometimes the renewal of choice is too much to take in. That happened to a man named Norman McIntosh. Released in 2016 after being wrongly incarcerated for fifteen years, he ate a first meal in Chicago with his lawyer, Jennifer Blagg.

"When we get to the restaurant, the server comes up and she's like, 'What would you like to drink?' Blagg said. "And he said, 'Juice.' So she says, 'Okay, we have pineapple juice, apple juice, orange juice,' and some other kind of juice. And he just looked at her blankly. He hadn't been able to choose what he wanted in fifteen years. Just the choice of what to get to drink was overwhelming to him."

"I feel emotional talking about it," Blagg continued. "If you imagine that it's overwhelming to figure out what choice you want to drink when you have five options, what is life going to be like? How hard is it going to be to adjust?"

First Meal captures such moments and how they came to be. The twenty-five paintings selected by Julie Green are derived from and inspired by questionnaires that exonerated people volunteered to answer about the food choices made on the day of their release. The project arose as an extension of Green's earlier work on capital punishment, *The Last Supper,* in which she painted, on ceramic plates, the last meals of more than one thousand condemned men and women before their executions as recorded in prison documents and newspaper accounts.

The text accompanying each *First Meal* image, written by Kirk Johnson, goes beyond the description of the art, as in a typical catalog. Johnson's short essays are based on his reporting on the cases, including interviews with exonerees and other sources, with the goal of providing a broader context about the criminal justice system and each person's journey through it. Some of the chapters focus on food and the specific meal that an exoneree ate on release, while in other chapters food is barely mentioned at all. Partly that is in keeping with the variation of exoneree experience; the post-prison meal was transcendent and magical for some people, barely noticed for others in the blur of newfound freedom. Green also felt strongly that each *First Meal* story should be unique and without format—no two chapters alike, as in the art itself.

No place in American society can fully escape the trail of error that haunts these pages. Nor can any individual say with certainty that he or she, if put in the place of a mistaken witness or victim, would have seen the truth and shouted it out in time. Error can be inadvertent or deliberate, a product of high ideals that miss the mark or corruption that rots truth from within. And in thinking through that chain of causes and consequences, another premise of *First Meal* emerged: that in a democratic society, we are the system and the system is us, created by our own choices and our willingness to examine and follow through on the choices we make.

That insight in turn led to the way the book was written, in alternating sections by the authors to better emphasize the point that seeing—bearing witness—is how democracy and the criminal justice system survive and retain their validity. The power and importance of individual witness has only deepened during the work on *First Meal*. The images of George Floyd's murder in Minneapolis in 2020, filmed by a teenager named Darnella Frazier, galvanized America and much of the world about questions of race and law enforcement, and were crucial in the conviction in 2021 of Floyd's murderer, a former police officer who knelt on Floyd's neck and stopped him from breathing. We witnessed. And we were changed by it.

But what this book is not about seems important to state from the outset too. Don't look for an academic monograph about art, a political polemic, or a deep-dive treatise into the structural causes of criminal justice failure. *First Meal* is a lens, first and foremost, an eye that opens to the minutiae of the world and lets us in. Each of the images is unique to that individual, and so too is the goal of the text accompanying that image. It's not the last word on what happened or why, but simply a spotlight of art and explanation capturing the moment of a first meal, or an exoneree's journey before or after that meal.

Some exonerees couldn't be contacted, or declined to be interviewed for reasons that neither Green nor Johnson, nor anyone else who hasn't been through the experience of wrongful conviction, has the right to challenge or question. To disappear into the world and be left alone is an expression of choice too. Some exonerees shared only bare details, while others were interviewed repeatedly; blocks of text from some of those interviews, lightly edited, are set apart in the chapters. Some stories were told through court documents or police transcripts, and some more obliquely, in cases where an exoneree didn't want to be identified by name.

The coauthors' voices, in first person conversational text, are different and deliberately so, reflecting their different perspectives and backgrounds. Green's voice usually comes first, describing the art and the elements that inspired its creation. Those comments are in many cases brief. As Green often said, art speaks to the viewer or does not, and must ultimately stand on that ground. Johnson brings a journalist's perspective to bear, as a former criminal justice reporter and longtime national correspondent for the *New York Times*. Johnson and Green's partnership extends back to their first meeting more than a decade ago, when he wrote for the *Times* about *The Last Supper*. Their friendship deepened through the work on *First Meal*, especially after Green was diagnosed with ovarian cancer in 2019. She died in October 2021 at age sixty, just as *First Meal* was nearing completion; she continued to paint and create until the final weeks of her life.

The book's images and stories have been structured into three parts. The first is called "Geography," with images and stories about the scope and scale of error in criminal justice. "Journeys," the second section, focuses more on the individual pathways of exonerees and on community connections that shaped their lives before, during, and after prison. "Strategies," the final section, is about the deeper wells of experience and survival—faith, community, family, work, art—and the cautiously optimistic indications of structural change in the justice system as the awareness and costs of wrongful conviction have sunk in.

Of course, on a certain level, *First Meal* is also about food, which Green was joyfully passionate about too, especially the produce from her garden. We eat. We are animals, a branch of the ape family. We are rooted in the tribal and genetic echoes of our past, but we build cathedrals of meaning around whatever we touch and wherever we have trod upon earth. Release and redemption are never simple. But neither is a gooey slice of pepperoni and cheese.

PART 1 Geography

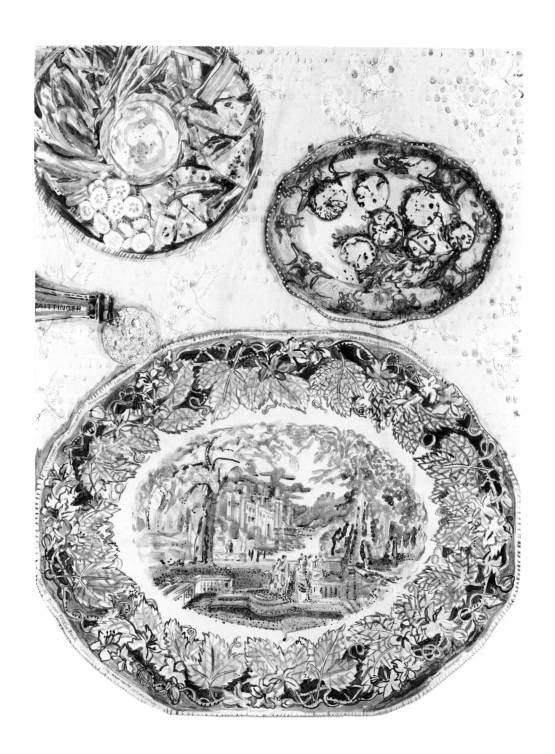

Champagne for Kristine Bunch

The history of error often begins and ends with an arrogant certainty of belief: the Grand Inquisitor knowing heresy when he sees it, the detective who believes with bedrock confidence that he can spot a lie or a guilty perp, the prosecutor who knows the truth and is thereby justified in withholding evidence that could potentially exculpate a suspect.

We're not a society that acknowledges or rewards the value of uncertainty. In a courtroom especially, a prosecutor or expert witness who tentatively qualifies the evidence is probably doomed. Jurors want certainty and definitive authority. And in Kristine Bunch's case, that's what the state delivered, even though in the end much of what they presented unraveled into the flimsy fraud it was.

Bunch spent nearly seventeen years in prison after jurors believed the state's reconstruction of what happened on the night of June 30, 1995, when a fire broke out in the trailer where she was living with her three-year-old son, Anthony, in Decatur County, Indiana. At the trial, a chemist and expert witness for the prosecution testified that he had found evidence of an accelerant in Anthony's bedroom. And that evidence, prosecutors said, showed Bunch to be a killer. The jury agreed and Bunch, then twenty-two years old and pregnant, was sentenced to sixty years in prison.

Bunch became a double victim, losing her son and then her own future. Her life was derailed by the dangerous appeal of absolutes.

"We've become so dependent upon the concept that science is inviolate," said B. Michael Mears, a defense lawyer who spent thirty years arguing death penalty cases and now teaches evidence and forensic science. Defense lawyers, Mears says, are often untrained in how to challenge a scientific witness in cross-examination, and jurors are often too ready to accept what an expert says. "You get a scientist who comes in properly presented, full of credentials, and the

2018
47 x 34 in.
acrylic on Tyvek
NoMad Hotel Collection
(London)

jurors can almost relax at that point, and say, 'Oh good. I don't have to carry the burden of making this decision. It is this scientist who's made it for me.'"

When the truth finally broke through for Bunch, years after her conviction, it came suddenly and completely, refuting what the learned, credentialed scientific expert had said. "It was almost twelve years later when my attorneys got a subpoena for that file and discovered the original report said nothing had been found in my son's bedroom," Bunch told me.

Why did the chemist say what he did from the witness stand? Why did he go beyond the evidence, to declare more than the facts could bear? Bunch doesn't know, and probably will never know.

"He died a couple months before I got out. There's no way to ask him what his thinking was, what his motives were," she said. "So you wonder if it's just, you know, he was in a job and felt like he was untouchable and he was doing the right thing for what he thought was right. I don't know."

On the day of Bunch's release from prison in 2012, her lawyers asked whether she was hungry and what she wanted to eat for her first meal out. Seafood please, she responded. But the restaurant where her family and legal team gathered in Columbus, Indiana, about three hours from the prison, didn't have seafood on the menu.

"They had wonderful little meals. You can get steak, you can get sandwiches," she said. "But no seafood."

So the chef, notified in advance of Bunch's arrival and her story, found a way: he went out and bought seafood to make a special meal in her honor. "The chef made me seared scallops with cheese grits to welcome me home and tell me congratulations. And we had platters of meat and cheese and vegetables and homemade peach ice cream," she said. The lawyers popped champagne.

> I don't remember eating a whole lot, but I remember just feeling kind of surreal, you know, like you're in an alternate reality. I mean, I could get up and go to the bathroom by myself and there was nobody telling me I had to wait my turn or it wasn't time to go to the restroom. And you can close and lock the door behind you and just be on your own. I remember I got really happy because in the bathroom they had different soaps and hand lotion and tissues and feminine products and all this stuff, just sitting out for their customers to help themselves. In prison you're lucky to get what you need.

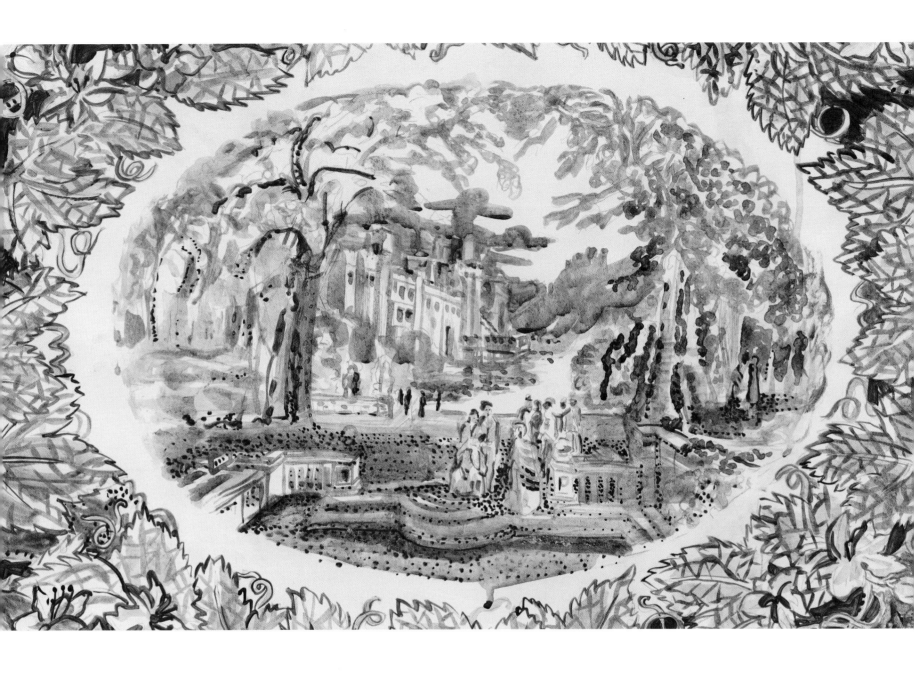

Such a tiny, trivial act: closing a bathroom door and clicking the latch, feeling a desire for privacy and being able to achieve it. But put yourself in Bunch's shoes at that moment. See her there in that room. That she could for the first time in years be the person who controlled the lock on the door held a universe of meaning. —KJ

The idea for *First Meal* came from a colleague at Oregon State University, Jim Folts. Seeing *The Last Supper* series on death row inmates, Jim suggested that when we no longer have capital punishment, I should paint one plate as a kind of mirror image and celebration: an exoneree's first meal on release. It was a great idea that led me to start thinking more about the margin for error in our legal system. Capital punishment numbers are way down, but it is not abolished; the problems of wrongful conviction persist. That led me to a *First Meal* series separate from *The Last Supper*.

I met Kristine Bunch at an arts event for *The Last Supper*. That afternoon, I heard her story, with all its haunting turns, dead ends, and mistakes.

When I started work on the painting itself, though, I was still just beginning the *First Meal* series, not yet sure what it would become. Perhaps for that reason I found myself—like Bunch, in her legal journey—going through a lot of false starts and dead ends.

I made more prototypes than usual, experimenting over and over before settling on a substrate of Tyvek, an archival material used in building construction and protective clothing. To suggest the passage of time, a Utopian, Victorian flow-blue transferware holds the food and Bunch's words, "Exciting but very scary. It was just unreal, a moment snapped out of time, like a dream that I expected someone to come snatch." I learned much from Bunch. The beautiful red cardinal, Illinois state bird, was used as a signifier of place, but also of scope. Like wrongful convictions, cardinals spread across America. Seven states have chosen this bird as a symbol. —JG

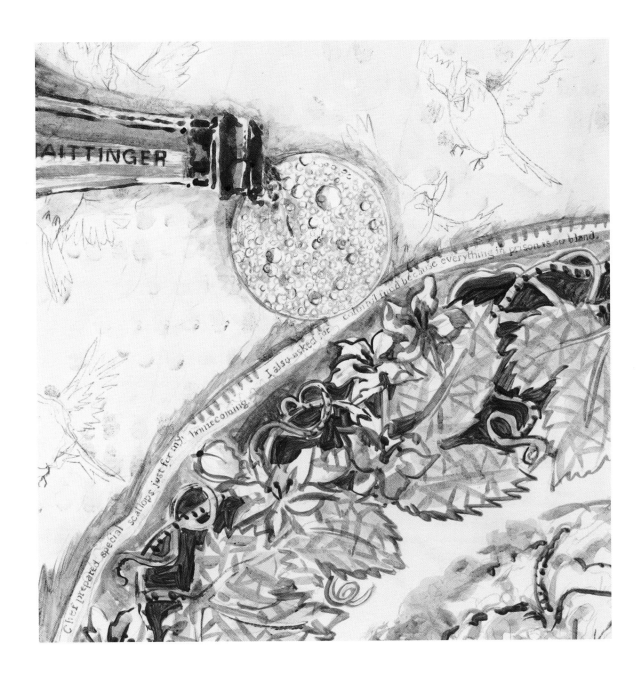

AITTINGER

Chef prepared special scallops just for my homecoming. I also asked for color, I lived because everything in prison is so bland.

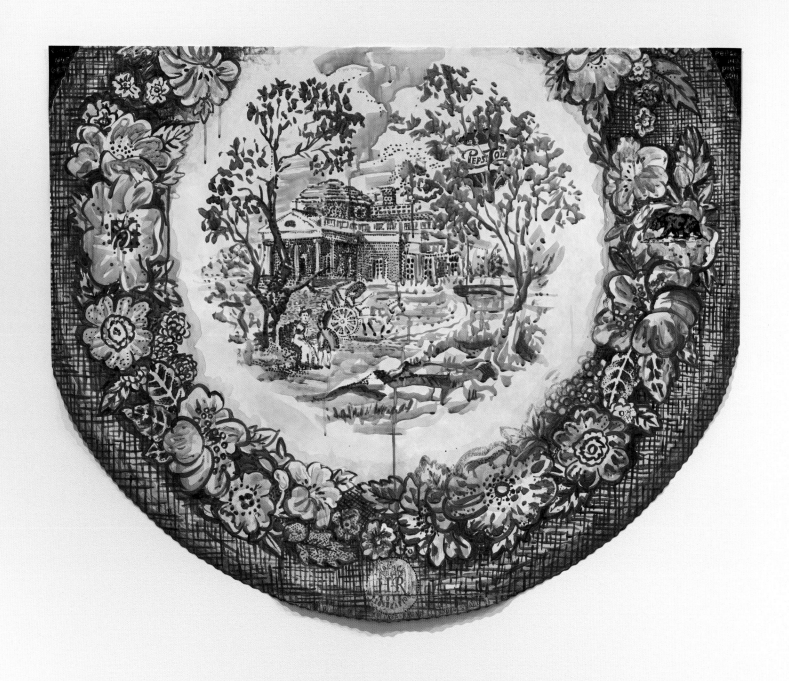

Pepsi-Cola Monticello
for Horace Roberts

Thomas Jefferson enslaved over four hundred people at Monticello. That felt meaningful to me in thinking about Horace Roberts. The notion of time—endured in prison, or back through history—is part of what I had to try to understand in painting this first meal. Roberts's food story, and the simple choices he made, came to me through Instagram. A California Innocence Project video showed him in the back seat of a car just after his release. He smiles between gulps from a bottle of Pepsi, a taste he craved if only because it was difficult to get in the prison, which had an exclusive contract with Coke. A Spode plate from our cupboard, Monticello pattern, is reproduced and holds the California state flag and the Chick-fil-A logo—which was also part of Roberts's meal. Then there is a Pepsi bottle cap. Big. A bottle cap as big as the sun. —JG

2019
38 x 47 in.
acrylic and glow-
in-the-dark logo
on Tyvek

Twenty years.

 The number is round and hard. Two full decades. A generation. Five presidential terms of office. Count it how you want, Roberts endured it, knowing he was innocent of murder and that a chain of tiny details had led a jury to believe otherwise. A coworker named Terry Cheek was murdered by a lake. A wristwatch that looked like Roberts's was found near the body. A clumsy lie uttered in embarrassment to conceal an extramarital affair with Cheek made Roberts look guilty in the eyes of the police. All the while, another man's motive for murder went unexamined.

 "What happened to Mr. Roberts is an absolute tragedy and a travesty. And our system of justice is designed to make sure that outcomes like this do not happen," said Michael Hestrin, the district attorney in Riverside County, California, in announcing Roberts's exoneration in October 2018. And yet, Hestrin added, "It happened in this case."

Three jury trials.

How many attempts it took, with only circumstantial evidence to go on, for a panel to finally convict Roberts of strangling Cheek and leaving her body by the lake.

Fifteen years.

How long it took to test the DNA of the skin under Cheek's fingernails, crucial evidence of her fight for life. It was not from Roberts, but another man who'd been questioned by the police and then ignored. The wristwatch, which prosecutors said was so unique that it must belong to Roberts, was not his either, and not that unusual.

Five years.

The agonizing stretch of time it took for the system to formally acknowledge the flood of errors that had washed over and through Roberts's life, and for prosecutors to stand up in court and declare him "factually innocent."

Twenty-five thousand years.

The cumulative total of wrongful years behind bars of the nearly twenty-eight hundred people, including Roberts, whose cases have been documented by the National Registry of Exonerations. The registry, a joint project of the University of California Irvine Newkirk Center for Science and Society, the University of Michigan Law School, and Michigan State University College of Law, has reported and summarized every known exoneration in the United States since 1989. The average time served for a crime those people didn't commit was eight years and eleven months.

Mere minutes.

Roberts's first meal after release was that of a man in motion. He was headed to the airport, flying home to his family in South Carolina. That was the urgent priority: making the plane, leaving California behind. They stopped at a Chick-fil-A near the Riverside airport. Pepsi with chicken, a scarfed-down meal in the car and don't look back.

"That hurt, that really hurt going down," Roberts said, wincing but smiling as he took a giant gulp. —KJ

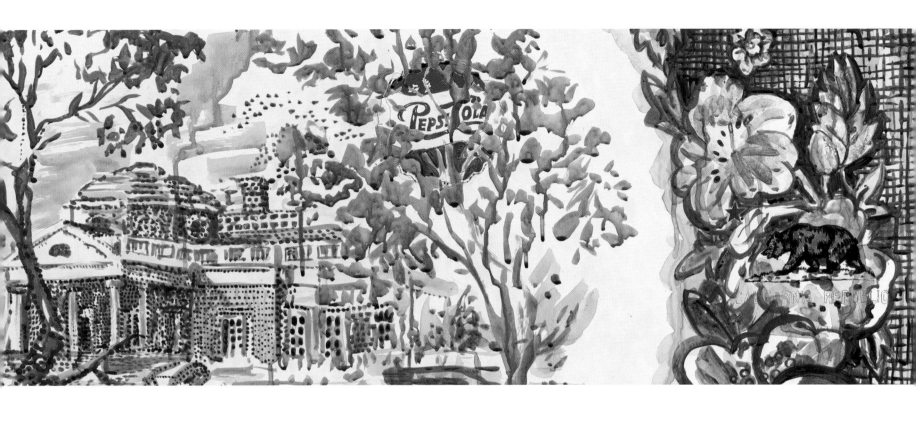

At Home with Family

2021
50 x 36 in.
acrylic, fabric, thread, 24K gold,
glow-in-the-dark paint
on Tyvek

Black individuals are seven times more likely to be wrongfully accused of murder than whites. Stop for a moment and think of that. Read the sentence again, slowly. It's still impossible to truly grasp. As a white woman of privilege, I have no idea how it feels to be a Black male, or to be wrongfully imprisoned, or to live in fear of a wrongful accusation based on my color. I can only try to imagine these things, how one endures them, and how surreal it must be to go home after such an ordeal. Or whether you really can go home at all.

Some food stories are elaborate. Others, like this one, have less detail. The exoneree had a home-cooked meal with family. In a nod to my mentor, Roger Shimomura, the brilliant Japanese-American painter and performance artist, I chose a fukinuki yatai "blown away roof" perspective to portray a domestic interior in a lush setting. The viewer peers down, removed from the scene, which remains untouchable and out of reach, on some level unknowable. At the dinner table on the left sits exoneree Robert Hill. —JG

Hill was arrested in March 1987 and charged with the murder of two men in the Crown Heights neighborhood of Brooklyn.

That same month, I was in a courtroom myself, a young crime reporter for the *New York Times* covering the trial of Bernie Goetz, a white man from Manhattan who'd opened fire with a handgun on four young Black men as they approached him on the subway in what Goetz felt to be a threatening manner. Goetz's defense team portrayed him as an everyman New Yorker, a nebbish nobody crime victim who couldn't take it anymore, and in a time of sky-high violence and mayhem, his trial gripped the city and the news media.

Hill's case, by contrast, got almost no attention even though it was just as emblematic of the city's troubles. The Brooklyn District Attorney's Office later concluded that Hill had been set up by a detective named Louis Scarcella, a

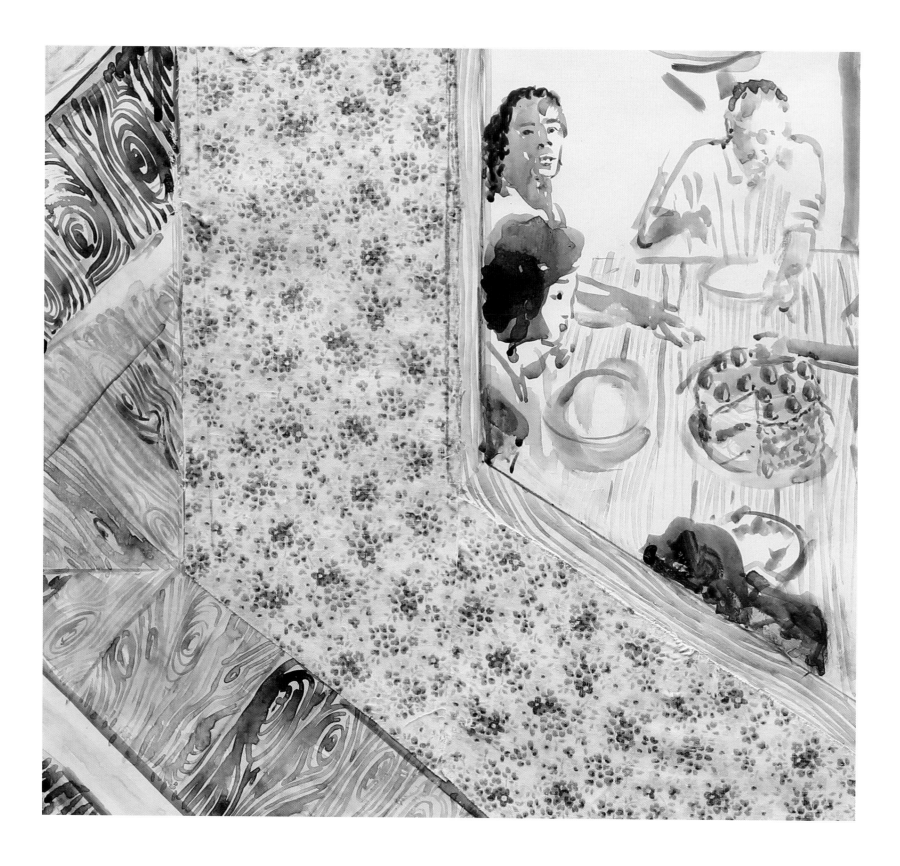

cigar-chomping wonder who could solve and close big cases like nobody else in one of the most dangerous corners of the city, using methods that no one at the time was looking at too closely. Hill got eighteen years to life. Goetz was convicted by his jury of having an illegally obtained gun, but acquitted of the more serious charges of assault and attempted murder; he served eight months of a one-year sentence.

Fear of crime ran through everything in New York at that moment. And the more I studied Green's glorious painting through the summer of 2021 while working on *First Meal,* and the more I read about the Hill case, the more I began to wonder who I was in 1987. Had I been following the wrong story? Were the pundits who talked about the Goetz case as the great symbol of New York's ordeal of crime all wrong and ignorant too? There was an overarching narrative of how things were coming down in New York, and other cities too where murder rates and drug crime had exploded, and it hinged on the idea that civil order was eroding, that control over the criminal element—a term that often bled into preconceptions about race—had slipped away. Only a few years after the Goetz and Hill cases, a crime-busting new mayor and former prosecutor named Rudy Giuliani would launch a strict new law-and-order policy in New York called "broken windows," which held that society could come apart if the tiniest crimes and frayed edges of the city weren't policed along with the big things.

And things did indeed feel out of control. The sense of menace was pervasive in the subway and in many parts of the city, like Times Square, that are now considered to be among the nation's safest urban spaces. My wife and I had been crime victims ourselves in the early 1980s; in our case, a home invasion and armed robbery by a young black man who climbed through our apartment window in Manhattan during a rainstorm and confronted us in the bedroom with a drawn pistol as we were playing cards on the bed in our underwear.

Who was I in 1987 when the judge banged the gavel to begin Goetz's trial and Hill was being framed? Where did the lines between reporter and crime victim intersect? I think I was fair to Goetz. Maybe too fair. A *Times* colleague, intending a compliment, said she couldn't tell from my stories where I stood on Goetz's guilt. Was he a "subway vigilante," as he'd been dubbed by the tabloids, a victim pushed so far that he'd felt he was fighting for survival? Or a delusional man whose fears had driven him to the edge of homicide?

Hill was exonerated in 2014, twenty-six years after his conviction, just before he might have been paroled. An analysis by prosecutors in Brooklyn found that three defendants including Hill had been set up for conviction by Scarcella, with compliant witnesses who were granted perks, including sex with prostitutes, if they agreed to point their fingers the right way from the witness stand.

The reexamination in 2013 of another famous Scarcella case, involving a man named David Ranta, is partly what opened the door for Hill's exoneration. Ranta was convicted in 1991 of murdering a beloved Hasidic rabbi and Auschwitz survivor, Chaskel Werzberger. But as the *New York Times* found in diving into the case, Ranta was falsely implicated by a convicted rapist who was trying to cut a deal for himself. Scarcella and his partner also broke rule after rule, according to investigators and legal documents cited by the *Times*—keeping few written records and allowing two dangerous criminals to leave jail and smoke crack

cocaine in exchange for their testimony. Scarcella, now retired, has consistently denied any wrongdoing in any of his cases. But more than a dozen convictions he helped investigate and secure have been thrown out, and New York City has paid tens of millions of dollars to settle civil suits, including $10.5 million paid in 2022 to a man named Shawn Williams, who spent twenty-four years in prison after he was wrongfully convicted in 1994 of murder.

In the fearful stresses of mid-1980s New York, society as a whole created injustice, fostered it and fed it, or looked the other way when it happened. The Scarcellas of the world were given oxygen by those fears. Many people who cheered and supported Goetz, or fantasized doing what he did if they found themselves cornered, were consumed by those fears. Police commanders and politicians who wanted the system to respond to fear—and just as importantly to look like it was responding—supported the narrative, as did journalists like me who came from all around the country and the world to write about Goetz and ignore Hill.

I studied history in college and drew great insight, or so I thought, in attempting to understand what people got right or wrong at any given moment of the past. What they did created the world we live in. But self-examination—what we saw and did in our own lives—must be part of the historian's burden too, and the journalist's. Horrible wrongs clearly still happen and will continue to happen. Humanity is flawed. But exposing our mistakes to the light, or seeing them in new ways, as Green would say, can only help. Hope hinges on the belief that we can learn from where we've come. —KJ

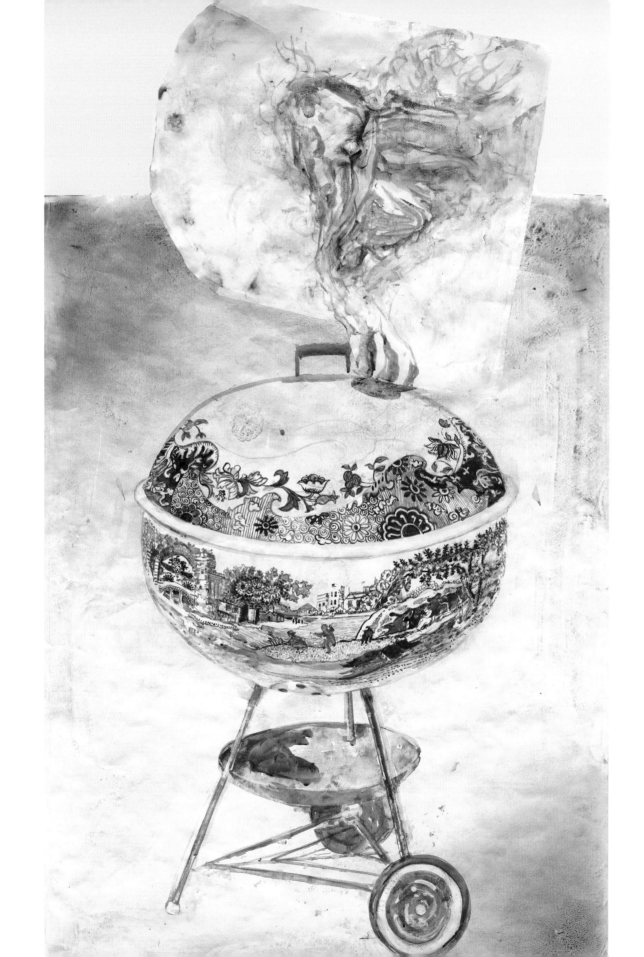

Savory Steak

A first meal after exoneration is a powerful image to think about, in its emotional sweep of beginnings and ends. It can feel, some exonerees say, like a whole life compressed into an hour, as the sensations of taste, smell, sound, and sight swirl and coalesce. It can appear enormous beyond belief, like the steak that Johnnie Savory ordered, accompanied by his lawyers for his first meal after release.

But Savory has another food image that resonates too: as a little boy at his father's side, learning how to make gravy.

He can still see it, decades later—how his father would stand at the stove, stirring and stirring for what seemed like forever through the eyes of a child. Preparing food requires attention, care, and time. That was one lesson. Another was that food was an expression of love, health, and ultimately self-worth. There was a wondrous kitchen chemistry that entranced Savory too, as simple ingredients were changed by heat and interaction to become different and better than their individual components.

> He prepared some baked chicken and then he took the broth from the baked chicken and made gravy using nothing but onions and bell peppers and flour. It was the first time I'd ever seen flour turn brown. He had one of those cast iron skillets, and he would just constantly stir the flour until it became a nice brown and then he would take the gravy and the onions and bell peppers and put them in there. Oh, but it was delicious! I didn't even want the chicken. I just wanted the biscuits and gravy because it was just that good.

Y. T. Savory was born in 1919—the initials were all there was to his name, so far as his son knows—and he endured many of the hardships of prejudice faced by Black men at that time in America. He worked in a rubber factory and a steel mill, and the family moved around, living in various states in the South and Midwest. Self-sufficiency to make ends meet in low-paying jobs was part of life. "When we had our first garden, he showed me how to plant seeds, how to till the ground. So yeah, I learned how to do it—wherever you're at, you can do it," Savory said.

2021
62.25 x 36.25 in.
acrylic, thread and
24K gold on Tyvek

Johnnie Savory's mother died when he was a baby. So Y. T.'s role model to his son was not just in how to live and thrive, but also how to do it alone, as a single parent. "He did whatever he had to do as a single, uneducated dad. That's what he did. He was a man among men," Savory said.

Johnnie Savory was arrested at age fourteen and charged with a double murder in Peoria, Illinois, in which two people were stabbed to death. A pair of pants with a small bloodstain were found by police at the Savory household and introduced as evidence. Y. T. Savory testified for the defense that the pants were his, that he'd injured himself at work and had the injury treated, all of which was documented.

The pants were also too big for Johnnie Savory. They didn't fit. But the jury voted to convict anyway and he spent almost thirty years behind bars. His father died while he was still in prison, on Johnnie Savory's twenty-sixth birthday, and though he was finally released on parole at age forty-four in 2006, it took almost another decade until he was pardoned by then-governor Pat Quinn.

But the legacy of Y. T. Savory lives on. And the family tradition of cooking lives on too.

"He always cooked good, healthy dishes for us," Johnnie Savory said of his father. "That's probably why I'm healthy today. I'm sitting here talking to you eating cucumber and lobster and crackers," he said in a telephone interview. As he spoke, almost like magic, I could smell the herbal cool of a sliced cucumber, and almost taste it, crisp on the cracker, with a pink fleshy wedge of lobster riding on top. Green should have lived to paint it.

Johnnie Savory has a daughter, born after his release from prison, and he's been teaching her the Savory family history. But he's also been keeping up with the latest kitchen gadgets, which he thinks his father would no doubt have loved as well.

"One of the best things I purchased was a pressure cooker/air fryer. You don't have to use all the normal things to prepare food anymore. So no need for oil anymore—you can cook more healthy foods today," he said.

Something also seems to have been handed down from the little boy who was so in love with gravy. His daughter is a vegetarian, having declared before she was five that she could skip the chicken too. —KJ

This composition came to mind fully formed. As soon as I read Savory's food story, I pictured a Spode porcelain Weber Grill. Most paintings are worked and reworked, but not this one. Sometimes a painting paints itself. And names itself. After all, what was the name of the restaurant where he ate? Savory. —JG

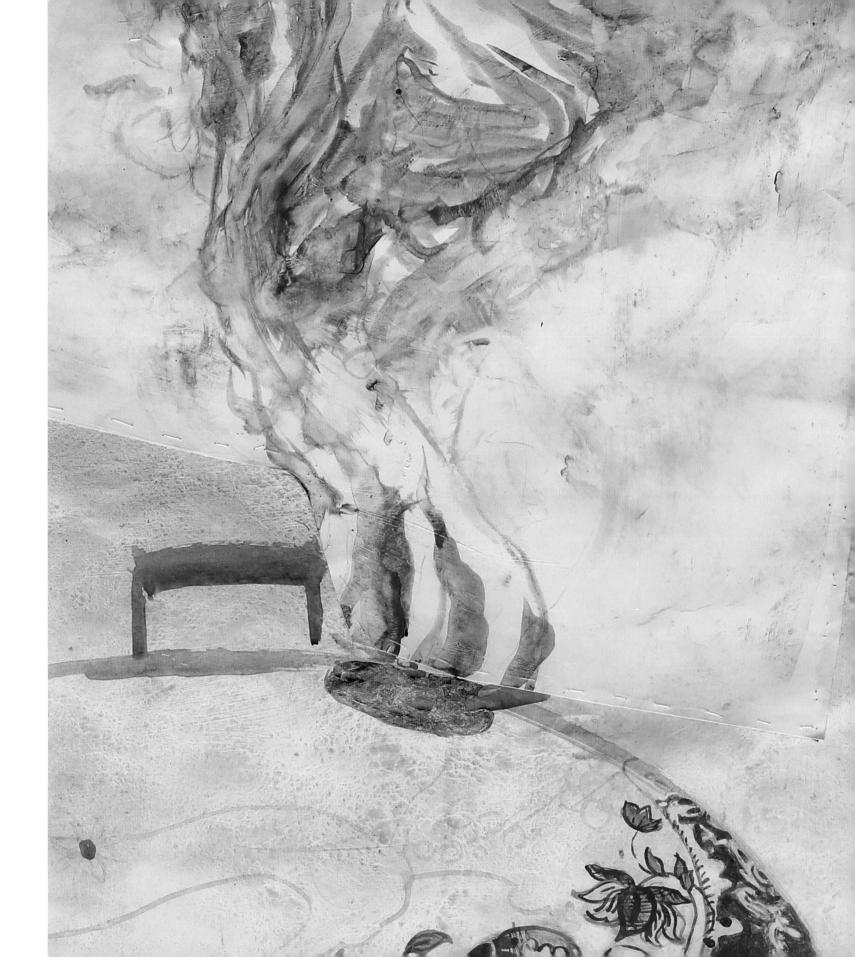

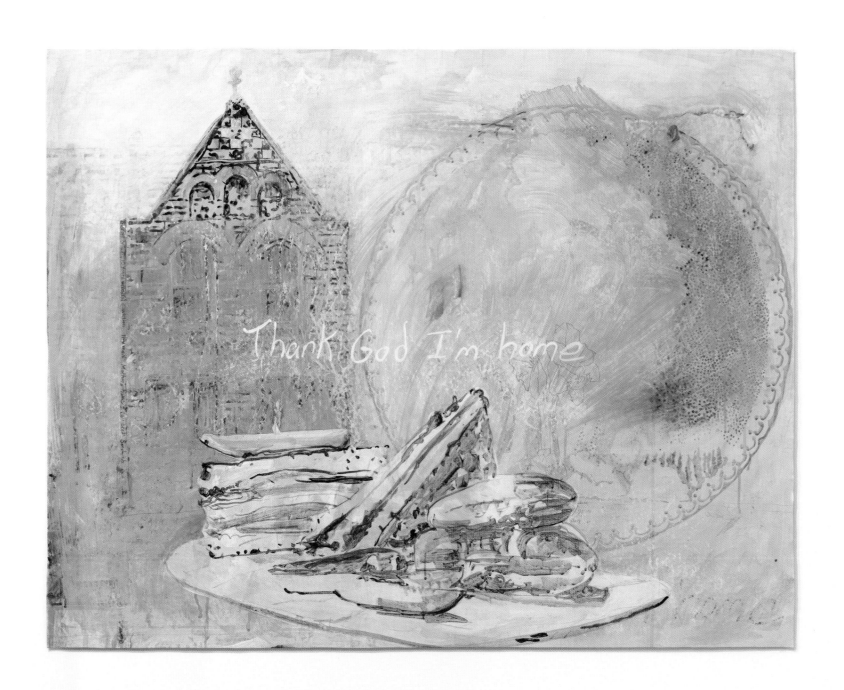

Thank God I'm Home, Said Marcel Brown

The painting includes both topical and personal colors, based on a photo showing newly exonerated Marcel Brown with Karen Daniel, each in Northwestern University's royal purple, leaving the courthouse. The turquoise and unbleached titanium refer to the paint on the bottom of Oregon State University's Dixon Pool, which I stared at during the month working on the composition, swimming laps as I considered how to capture Brown's story. Movement seemed a part of the chemistry, finding the path to get to where you need to be. Fittingly, the corned beef sandwich was moved three times before finding its place. While painting, I kept thinking of Brown's words on the interview form, until his cry of gratitude and faith became my own: Yes, Marcel, thank God you are home.
—JG

2019
35.5 x 46 in.
acrylic on Tyvek

The idea of home is bound up in the human experience. From Homer's *Odyssey* on down through the ages, a protagonist's efforts to find a way back—to hearth, family, and community—is a narrative arc that instinctively grips us. Home represents safety, security, and stability in an unpredictable and dangerous world. It might just be an idea, and not a physical place at all. And even if we get there it might not contain the love and harmony we'd imagined. Life is not so clean and neat as that; poverty, oppression and dysfunction stalk the world too.

But despite it all, there is a place we hold out for and where we seek shelter. In Brown's interview with police detectives, which went on for more than thirty hours, his need to find a way home—to escape the nightmare that was tightening its grip around him—echoes like the chorus of a dirge. Twenty-three times, variations of the word "home" are expressed in the stark and stumbling exchanges. Seven times, each more excruciating than the last, he asks if he can speak with his mother. Brown was eighteen years old.

First time:

Brown*: Can I get my phone, call my mama?*

Detective*: Give us a couple minutes.*

Second time:

Brown: *Could I call my mama?*

Detective: *In a few minutes. We got your phone on the outside here.*

Third time:

Brown: *Call my mama.*

Fourth time:

Brown: *Can I call my mama?*

Detective: *Give us five minutes. All right?*

Fifth Time:

Brown: *Can I call my mom?*

Detective: *We'll let you call her in a little bit.*

Sixth time:

Brown: *Can I talk to my mom?*

Detective: *Can you talk to your mom? How old are you, man? You're eighteen, right?*

Brown: *Yeah.*

Detective: *Yeah, you don't need—you don't need your mama on this. Okay?*

Brown: *I got to tell her something.*

Seventh time, day two of the interrogation:

Brown: *Can I call my mama?*

Detective: *In a little bit.*

What Brown didn't know—information withheld from him—was that only a few hours into the interrogation, a lawyer hired by Brown's mother showed up at the police station. He asked to see his client and wasn't allowed in. That failure by the police to allow access ultimately led a judge, years later, to throw out the entire interrogation and confession. The door the detectives had kept closed swung open, revealing what really happened as the officers repeatedly denied Brown's requests. The charges were dropped, but only after Brown had served seven years of his thirty-five-year sentence.

In an interview in 2021, I asked Brown about food. He told me that as he was being questioned, the detectives brought him a bologna sandwich, which he

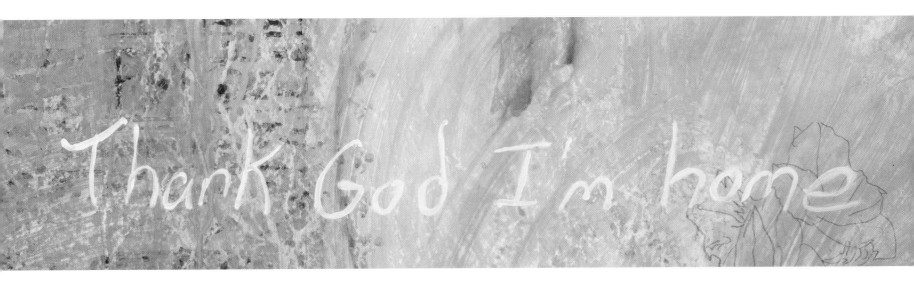

Thank God I'm home

couldn't bear to look at in the stress of the moment. "The walls were caving in on me," he said. "I wanted to get out of that space. I just really wanted to go home."

He could barely eat his first post-release meal either. He'd gone home from prison to his mom's house in a suburb of Chicago. His stepfather ordered takeout.

A corned beef sandwich. That was at my mom's house. My stepfather was at a corned beef restaurant when I got out—he went to get me something to eat. But when I first bit into the sandwich, it was so flavorful, it felt like I was eating contraband, and everybody was watching, and it was like I wasn't supposed to have it. It was too good and I wasn't used to it. My mind was kind of like still in there, because I was free no more than what, two hours. It just . . . it just felt like I wasn't supposed to have it.
—KJ

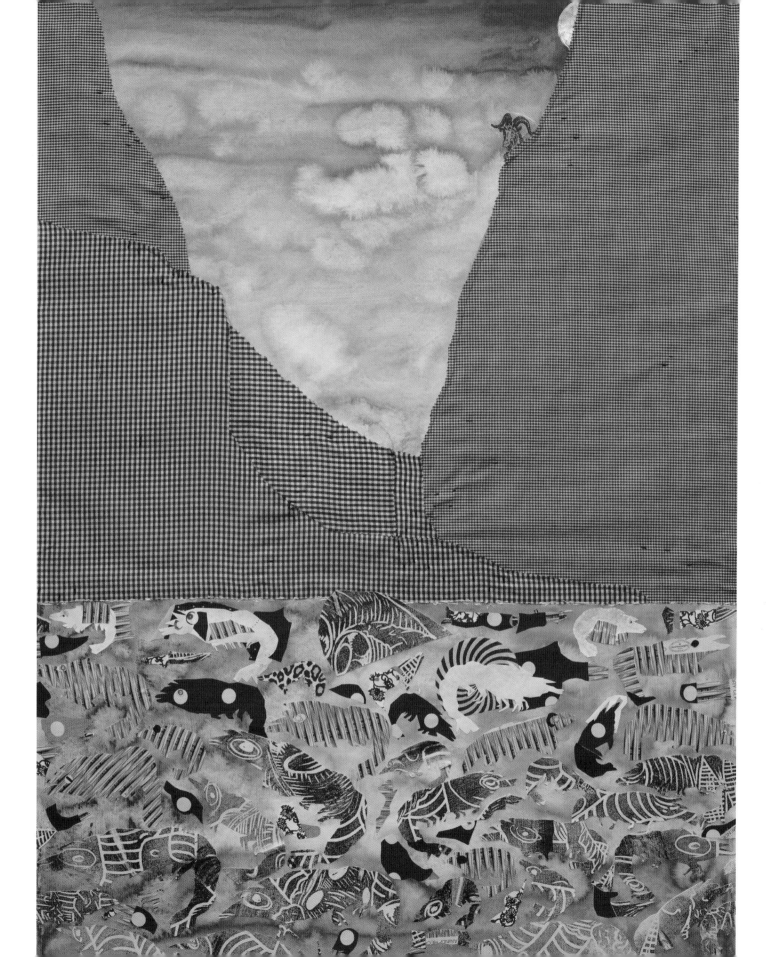

Shrimp and Grits at Little Goat

I sew. Mom taught home economics and still sews my skirts. It seems I could sew before I could walk. And I was shaped by the places I've loved. This painting captures an Illinois first meal, but a friend from China said it looks Asian and it does. I was born in Japan, lived there as an adult, and am fond of Asian design.

Exoneree Patrick Prince had a delicious first meal of rock shrimp and grits at Little Goat Diner in Chicago. A gold sun represents the grits, and the corn from which grits are made is the gold of the Midwest. Peering out from behind a cliff is a plastic goat head logo, cut from a bag in our closet that held a new cashmere sweater. I look around and use what's on hand, improvise, recycle. The gingham cliffs are cut, sewn, quilted.

Shrimp are creepy-looking but tasty. I planned to make a few decorative shrimp with the appearance of reverse applique, but the composition wanted more, more. His plate should be brimming with shrimp. —JG

2021
49 x 36.25 in.
acrylic, cloth including hand-printed cotton by Clay Lohmann, thread, paper, 24K gold, and glow-in-the-dark paint on Tyvek

Prince came back home in May 2017 to Chicago, a city that had shaped him, growing up. He ate in a neighborhood that had fundamentally changed in the twenty-four years he'd been gone, at a restaurant that hadn't existed when a wrongful conviction in the early 1990s took his life off the rails.

Little Goat Diner, which opened in 2012 in Chicago's West Loop neighborhood, deliberately and enthusiastically throws tradition out the window with an exotic mashup of cultures and cuisines. A dish called "This Little Piggy Went to China" features sunny-side up eggs with Sichuan sausages on a scallion cheddar biscuit; "Bull's Eye French Toast" is served with crispy chicken. The Asian-fusion burrito comes wrapped not in a tortilla but in Indian flatbread.

Three miles southwest of the restaurant, in late August 1991, a thirty-seven-year-old man named Edward Porter was shot and killed near the intersection of South Francisco Avenue and West Flournoy Street. It's an easy stroll from the

diner in fine weather. But worlds are contained in that walk. Much of the West Loop was, for decades, an uneasy borderland between the rough district of rescue missions, warehouses, and dive bars to the west and the glossy glow of Michigan Avenue and the Magnificent Mile to the east. The area was transformed during Prince's years away, as the old Chicago and the new were stitched together.

From Little Goat a person heading southwest might wander into Skinner or Union Parks along the way, or push up north for a detour onto the campus

of Malcolm X College. After crossing under Interstate 290, he might find the sidewalks crowded, depending on the time of day, with employees out to lunch or coming to or from work in their blue scrubs at the cluster of hospitals in the Illinois Medical District—Rush University Medical Center, The Jesse Brown VA Medical Center, or John H. Stroger Jr. Hospital.

History stretches out in every direction. Going east from the restaurant it's less than half a mile to the site of one of the signal events of the American labor movement, Haymarket Square, where workers rose up in 1886 to fight for better conditions and hours in the city's factories and slaughterhouses and to protest police violence. Haymarket became a symbol of labor-conscious Chicago, a rallying cry for unionization and workers' rights—but also a historical crime story in its own right as questions swirled for decades about who threw a bomb that day and who was chosen for punishment.

A ten-minute walk in the other direction takes you to Harpo Studios, the entertainment complex created by Oprah Winfrey. Winfrey's project was just gathering steam in the early 1990s, still an island in a tough neighborhood, only starting to build the momentum that would lead to new residential and commercial life in the area, and to the establishment of restaurants like Little Goat.

Prince was nineteen at the time of the murder. He came to the police's attention after an anonymous caller put him at the scene of the crime, and was then, he said, coerced into a false confession. At the trial, the interrogating detective denied committing physical abuse to extract a confession, and the judge allowed the statement into evidence. With no eyewitnesses, Prince's confession became the heart of the prosecution's case, and he was convicted and sentenced to sixty years in prison.

Over the next two decades, through an unsuccessful appeal for a new trial that Prince filed himself from prison, through years he could never get back, the city he'd known evolved, shifted, and grew. The anonymous caller, meanwhile, had been found—and had admitted to making the whole thing up, angry at Prince over a girl. He'd just wanted to get his rival into some trouble, he said, and hadn't imagined his call would lead to so much destruction.

Every place in the world has a story, and every person's journey through those places can change the path for those who follow. Mistakes, triumphs, betrayals, and risky ventures combine to create the fabric of a city that breathes and lives. And then a man sits down, come from a long way, to eat shrimp and grits. In the act of taking a seat, Prince once again became a citizen of the world. —KJ

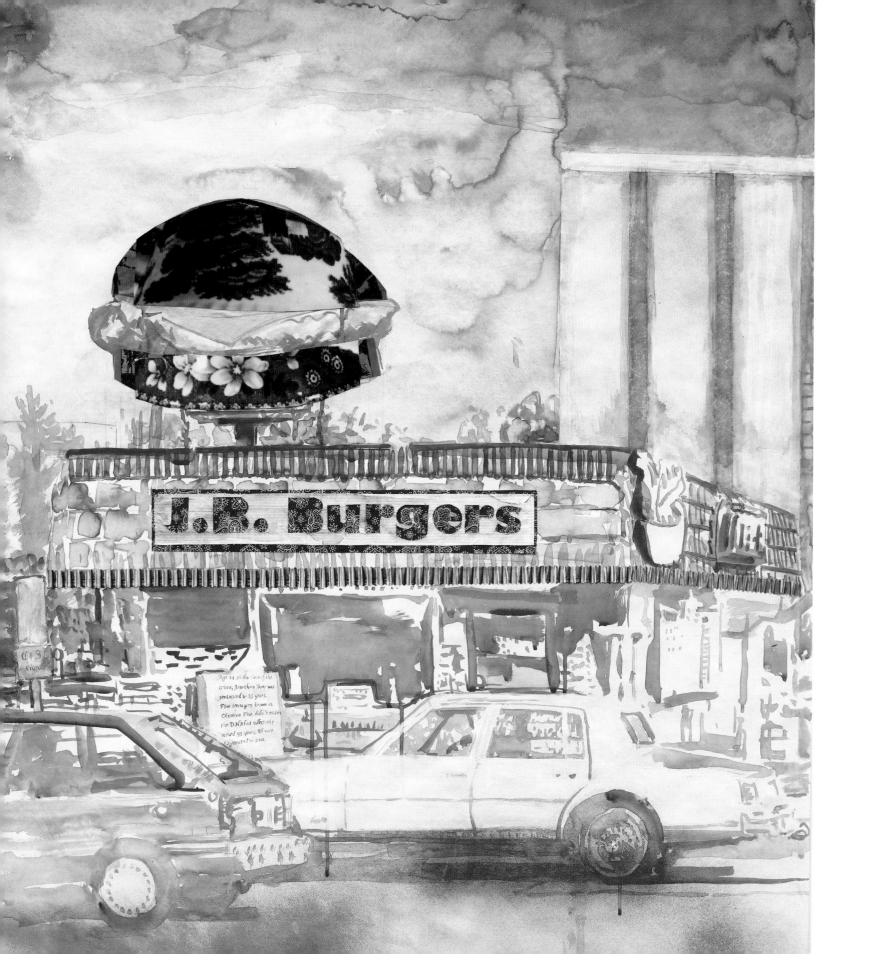

J. B. Burgers

As a kid, I loved find-the-hidden-object books in dentist office waiting rooms. Find zoo animals embedded in the trees, find food hidden in the restaurant. Now, find the years wrongfully imprisoned in glow-in-the-dark paint. Find the exoneree in the group. Find the fingerprint.

I have an idée fixe about fingerprints, still used at crime scenes but more often these days for opening a phone. We carry these small, unique prints; we are all potential printmakers. The beauty and authenticity of a fingerprint is an improvement over seeing a name spelled out. And each *First Meal* is signed with my fingerprint.

J. B. Burgers has a sign board in front of the restaurant mentioning the Dixmoor Five. Filling out an interview form for *First Meal* eight years after release, Jonathan Barr didn't list a restaurant name for a hamburger meal. I decided to create a restaurant for him to call his own, as unique to him as the arches, loops, and whorls of an index finger. J. B. Burgers. —JG

2021
48.5 x 36.25 in.
acrylic, cloth, thread, paper, 24K and glow-in-the-dark paint on Tyvek

The Dixmoor Five case is a horror story, starting with the victim, a fourteen-year-old girl named Cateresa Matthews. She'd been missing for twenty days when her body was found on December 8, 1991, on a path running along I-57 in Dixmoor, a working-class suburb of Chicago. Cateresa had been raped and shot in the mouth.

Five Black teenagers from Dixmoor, including Barr, were convicted and sentenced in the case, as a result of false confessions and induced testimony. Barr and his codefendants, James Harden, Robert Taylor, Robert Lee Veal, and Shainnie Sharp, collectively spent ninety-five years in prison for a crime that they didn't commit and that DNA analysis later showed they could not have committed. Semen recovered from the victim was retested, much later, and was linked to a man named Willie Randolph, who lived in Cateresa's neighborhood

and was on parole at the time of her murder, after a conviction for armed robbery.

How do you assess the cost and waste of the lost years experienced by those five young men? How in the end could you ever begin to make anything whole again? Lives can't be restored. Confidence in police and prosecutors, once eroded, is hard to rebuild.

Money, for better or worse, is how the American system measures redress and culpability. In 2014, the state of Illinois agreed to pay $40 million to settle civil claims brought against the state police on behalf of the Dixmoor Five. That same year, New York City paid $40 million to five young Black and Hispanic men in the Central Park jogger case, all wrongfully convicted of beating and raping a white woman in New York in 1989. In 1999, Cook County, Illinois, agreed to pay $36 million to settle a lawsuit brought by the Ford Heights Four, who spent years in prison after a wrongful conviction for rape and murder.

But it's uneven terrain. Though thirty-six states and the District of Columbia had statutes in place to allow compensation for wrongful conviction as of mid-2021, up from only about a dozen in the late 1980s, nearly all cap the amounts that can be paid, or impose other restrictions. Florida, for example, forbids a wrongfully convicted person from receiving compensation from the state if there is a prior violent felony on the person's record.

Many exonerees, facing barriers or lack of legal assistance, don't even try. Across the nation, only about 54 percent of people who were incarcerated in states with compensation laws sought financial reimbursement for the wrongs committed against them as of the middle of 2021 as Julie and I were working on this book. Seventy-five percent of those seeking compensation had received it as of that same date, with payments averaging out to about $70,000 for each year of injustice, according to research by Jeffrey S. Gutman, a professor of clinical law at the George Washington University Law School.

Legal scholars like Gutman say that as civil settlements ripple through criminal justice, the financial costs have pushed elected officials to face the reality that errors and bad investigations aren't just disasters for the wrongfully convicted, but for taxpayers too. It costs the public money when the wrong people are convicted. But the growing awareness of costs can also potentially in-duce law enforcement officials to drag their feet and not to want to look, know-ing more than ever that exposing error or wrongdoing could come with a heavy price.

"The potential dark side to this, and I always worry about this a little bit, is whether some of these large awards cause people to keep their mouths closed. So, you know, 'We're not gonna dig into this one very deeply because if God

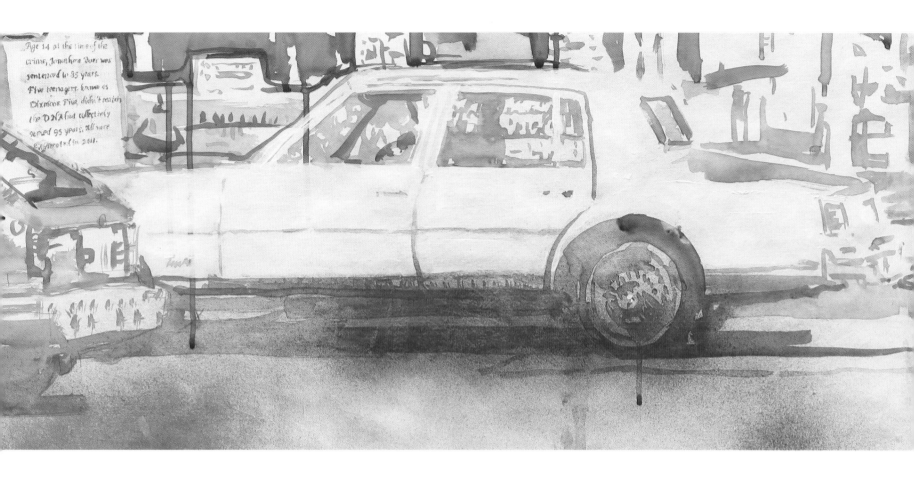

Age 14 at the time of the crime, Jonathan Barr was sentenced to 35 years. Five teenagers known as Dixmoor Five didn't match the DNA but collectively served 95 years. All were exonerated in 2011.

forbid it turns out we did something terrible, gee whiz, we're going to be on the hook for $10 million. So let's just not touch that one,'" Professor Gutman said.

In the end, human nature being what it is, errors and failures often only get found and exposed when pressure is applied.

In the Cateresa Matthews case, the police in Dixmoor were ordered by a judge to produce the rape kit for retesting as the exoneration effort for Hill and the other men proceeded. Officers came back to court and said they'd looked but just couldn't find it. So the judge said that perhaps the defense lawyers themselves would have better luck and should be given an opportunity to search through the evidence locker. And just like that, the rape kit was found.

"I think they had done a half-hearted search," said Jennifer Blagg, an attorney who worked on the exonerations. "And then when it came time for us to personally go look, they really looked." —KJ

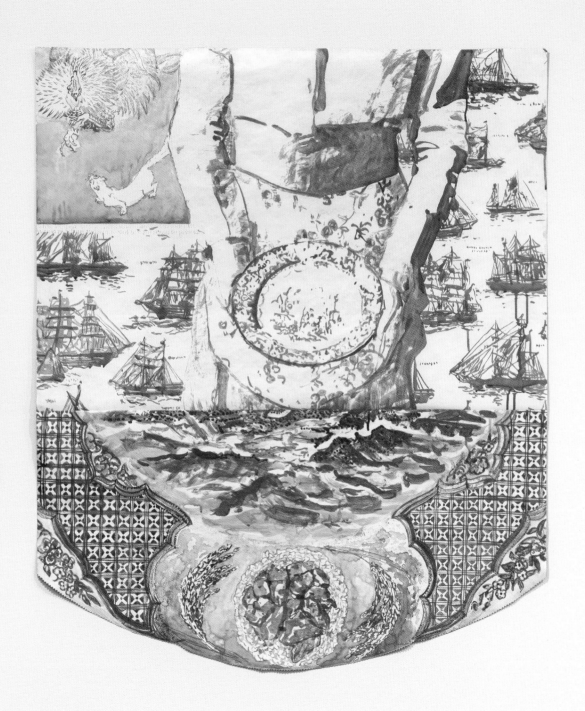

Liver

Since this exoneree wishes to remain anonymous, I was careful not to include anything that might reveal identity. There's no state bird, no state flower, no state at all. He ate liver and rice at his mom's home. Liver. The word blurred the more I thought about it and its roots. Liver. Lifer. Live.

All cases of wrongful conviction are shocking. Sometimes it's DNA that clears a person's name, but very often release comes only after a revelation of police or official misconduct, perjury, a lack of proper legal representation, or, as in this case, mistaken witness identification. While painting the image of a mother, based on a photo of me, a non-mother in a red apron, I considered the power of witness; you can get it right or you can get it wrong. I found a vintage print of a bird, a rooster I believe, talons ready, swooping down on a small, scared badger. The painting is made to look like a print in front of nautical wallpaper, and my text below the wildlife scene reads: "What happens to a witness who makes a false identification resulting in an innocent person going to prison?" —JG

Evolution honed our minds, through thousands of generations of hunting and gathering, to see patterns in things like wind, clouds, and animal behavior. We gauge the landscape for things that might help us or harm us. But then that same machinery turned on us. The ability and propensity to see patterns, neurologists have shown in numerous studies, also makes us susceptible to patterns that aren't real, to conspiracy theories or a belief that we can predict the next coin flip or turn of the cards at poker based on the five hands that were dealt before.

And because we are social creatures, memory works in a loop of social reinforcement too; if a circle of people around us remembers the details of an event in a certain way, we tend to find our own memories bolstered to conform to what the group saw or heard. A police investigator can nudge that train of

2019
42.5 x 36 in.
acrylic and glow-in-the-dark paint on sewn Tyvek. Painted on both sides and could be hung as banner
NoMad Hotel Collection (London)

error along—even subtly or inadvertently—by suggesting to a witness that the real suspect is in a lineup or photo array. And once the momentum starts, it's damnably hard to be the one who says, "You're all wrong, I know what I saw." We bend. We conform. And so the story and the pattern, however wrong or right, become more firmly embedded. What starts as mere possibility can become, by and by, unquestionably true.

This anonymous exoneree whose meal was painted by Green became the suspect in a rape because the real rapist was Black, and there were only a few Black men residing in the building where the victim lived and was attacked. So he was among the first people to be questioned by police. The victim then identified him as her attacker, and the circle closed. But everyone was wrong. The exoneree could have been excluded not just by his DNA, but by his blood type.

His desire for anonymity now is understandable. To be known and seen was disastrous in the fate that befell him.

But similar disasters of mistaken witness consensus are everywhere in the public record. It happened to a man named Lydell Grant. He was identified in 2010 by six eyewitnesses as the man who'd brutally stabbed a person named Aaron Scheerhoorn to death outside a bar in Houston.

All six were wrong.

Social pressures were partly to blame. One of the witnesses, who worked at the bar and saw some of the fight, didn't think at first that the killer looked much like Grant. But coworkers seemed convinced, and so, eventually, the doubter came to doubt himself and his earlier (correct) belief in what he'd seen, or not seen.

Memory is a dangerous, slippery, and easily manipulated property of the human mind, as fortune tellers, politicians, great novelists and detectives have known for centuries. A hint, a nudge, a glance—especially in the emotionally wrenching aftermath of a violent crime—can be all that is needed to guide an uncertain witness onto the glidepath of confident certainty.

"The detective knows who he wants them to pick," said Mike Ware, the executive director of the Texas Innocence Project, and one of Grant's attorneys. "It can be anything as blatant as, 'This is the person who did it.' It can be, 'Everybody else picked out this person. What do you think?' It can be like, 'Take a careful look at number two.'"

Then comes the reinforcement, which again can be deliberate or not. Memory gets bolstered by emotion, and by the praise that can be heaped on a witness for standing up and doing the right thing. Feeling good makes us more confident of what we saw, however uncertain our memories might have seemed at first.

Again, Mike Ware: "Once they pick that picture, once they've been steered to that picture, and once the detective and whoever else is there representing the police department gives them all this positive feedback about how courageous they are for helping them get this bad guy, then that becomes in their mind who it was. No matter who they actually saw—that becomes in their mind the actual perpetrator."

It was misbegotten confidence that brought disaster to a man named Ronald Cotton. He spent eleven years in prison in North Carolina after a rape victim named Jennifer Thompson-Cannino identified him as her attacker. When the truth finally came out through DNA testing and Cotton was cleared, Thompson-Cannino was wracked with guilt about her testimony. Cotton ultimately forgave her, which then allowed her to forgive herself, and they wrote a haunting and beautiful book together about their journey, with Erin Torneo, called *Picking Cotton: Our Memoir of Injustice and Redemption*.

Violent crime, attorneys and researchers say, hits us in profound and emotional ways that can affect memory and judgment. As jurors, witnesses and victims—and in fairness, police, prosecutors and judges, too—we're all susceptible.

"When that person says, 'That's who did it, there's no doubt in my mind,' you know, with the trembling finger pointing at them, that defendant's not walking out of the courtroom," said Ware, Grant's attorney in Texas. "I don't care if they do have an ironclad alibi; the jury is not going to believe the ironclad alibi. They're going to believe the eyewitness with a trembling hand." —KJ

PART TWO Journeys

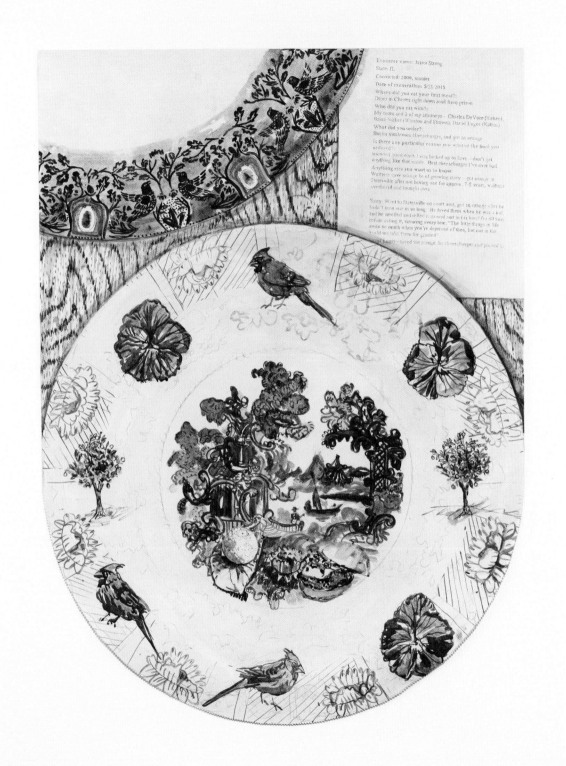

Holding Orange for Jason Strong

You can improvise to make some of your own meals in prison, cooking in your cell, as Jason Strong learned to do. Over the years, the prison food became worse and worse, cheaper and coarser to the point of being often inedible. So Strong adapted. You can make a kitchen tool with an extension cord and two paper clips jammed in at the end, called a stinger, that will boil water as the clip wires heat up; stinger-cooked ramen from the commissary can get you through. You can even heat the metal frame of your cot to create a kind of makeshift grill, and a half-decent burrito can be cobbled together if you can get the ingredients.

Necessity, Strong calls those improvisations. Choices driven by a lack of choices.

But that day in 2015, sitting down at a table in a real restaurant after so many years, it all felt overwhelming. The place was simple enough—a country diner, blue and white decorations, chicken-fried steak, club sandwiches, and apple pie a la mode on the menu. Bedrock Americana, deep-fried everything with a pickle spear on the side. The waitress, a thin woman in her thirties, seemed nice enough too. She stood by the table, waiting to write down what he wanted, food that would be prepared specifically for him back in the kitchen and set before him when it was done. The totality of that was almost too much to take in. He was out of breath, so excited and flushed, that the waitress finally asked him what was wrong.

"'You look like you just ran a marathon. Are you okay? What's happening here?'" Strong said, recalling the conversation. "And so we told her."

They told the waitress how he had been convicted of murder in 2000 at age twenty-four and sentenced to forty-six years in prison. How, in 2013, two full years before that moment in the diner, the Illinois attorney general and the Lake County state's attorney had agreed to re-investigate his case. And how the evidence against him then unraveled, with prosecution witnesses recanting their trial testimonies, as previously unexamined medical evidence from the county coroner's investigation pointed to another suspect.

2018
47 x 35 in.
acrylic on Tyvek

They told her how, on that very afternoon, May 28, 2015—just hours earlier—the criminal charges against him had finally been dropped. With his mom, Debbie King, at his side, along with three lawyers from the team that had taken on his appeal, Strong walked out of the grim, 140-year-old beige walls of Menard Correctional Center, jumped into his mother's car, and drove the mile and a half to the diner.

And now it was time to do what millions of people do every day and barely think about: order lunch. *What do you want?* He'd long imagined the moment, the day of his release—what it might be like and what he might do and choose after so many years of being told when to wake up and eat and sleep. He'd dreamt of his mother's stuffed peppers, her pork chops with scalloped potatoes, and her salmon patties. He'd fantasized about pizza.

But the thing that called out to him, suddenly and loudly, Strong told me, was a cheeseburger, loaded. Mushrooms, bacon, and fries. And so the waitress wrote that in the kitchen's code, "Bac Mush CB/FF," on order number 04467. Seven bucks flat for the works. The paper receipt was kept as a memento by one of the attorneys at the table who saw, even as it was happening in front of him, that Strong's first meal was a moment he would never forget.

But also never really understand. Like soldiers who say they can never explain what it's like to be in the middle of a war, and so too-often struggle to fit back into societies and families after combat, wrongfully convicted inmates are pushed together into a community and shaped for better and for worse. To Strong, it's a concept that was summed up perfectly in Aleksandr Solzhenitsyn's description of the gulag system of the Soviet Union—that the depth of the experience couldn't really be communicated: "Only those can understand us who ate from the same bowl with us," Strong said.

Years from that day in the diner, Strong has continued to push Solzhenitsyn's insight, becoming an advocate, blogger, and videographer in helping other wrongfully convicted people. But he said the memories still swirl in fragments of that day of release. Some are so vivid that he will remember them for the rest of his life, like the taste of the burger when the waitress finally brought it to him. Others are a blur, like the drive home back to Tennessee that night with his mother.

The subject of oranges came up in the restaurant. As people were finishing their meals, someone asked what else he'd hungered for and missed, through his years of confinement. "Oranges," he said. The prison sometimes had apples, but never oranges.

The waitress overheard. When she brought the check, she came back with something else from the kitchen. Walking up to Strong, she offered it to him with her hands: an orange.

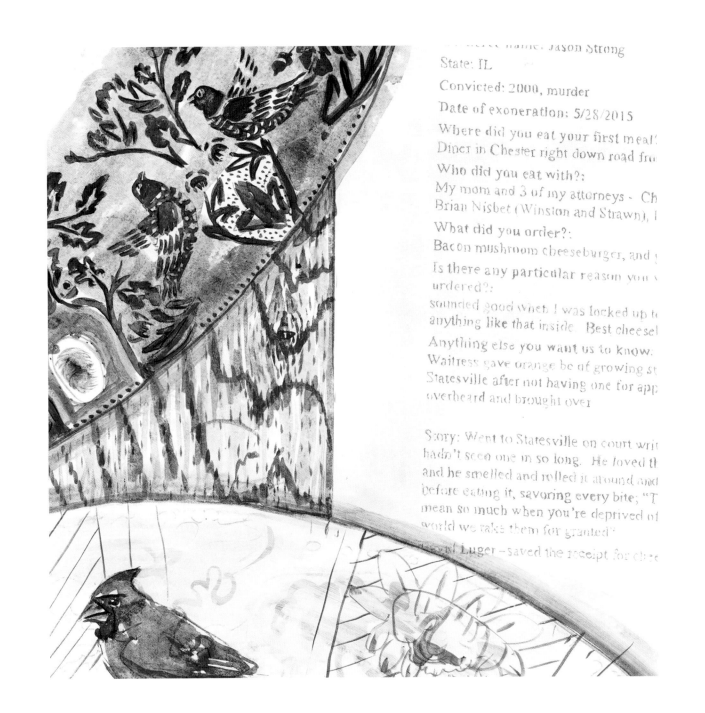

name: Jason Strong

State: IL

Convicted: 2000, murder

Date of exoneration: 5/28/2015

Where did you eat your first meal?
Diner in Chester right down road fro

Who did you eat with?:
My mom and 3 of my attorneys - Ch
Brian Nisbet (Winston and Strawn), I

What did you order?:
Bacon mushroom cheeseburger, and

Is there any particular reason you
urdered?:
sounded good when I was locked up to
anything like that inside Best cheese

Anything else you want us to know.
Waitress gave orange be of growing st
Statesville after not having one for app
overheard and brought over

Story: Went to Statesville on court writ
hadn't seen one in so long. He loved th
and he smelled and rolled it around and
before eating it, savoring every bite; "T
mean so much when you're deprived of
world we take them for granted"

evin Luger – saved the receipt for chee

"I admired the orange. I smelled it and I rolled it around in my hands and felt it and just enjoyed every minute of it," he said. "It just really stuck out to me as an important, pivotal moment. But also because it makes a great point about how often we take so much shit for granted. When we're deprived, those little things can mean so much."

What everybody that's going through prison would say is don't take shit for granted—enjoy everything, enjoy life, enjoy your freedom, enjoy the things that we have on a daily basis. Enjoy your families because you never know when you could lose it. Tomorrow you could be sitting at home enjoying a regular day, not thinking twice about it. Get a knock on your door and like that, your life is over and changed.

But the power to live for the moment and in the moment, to suck the juice of life as it comes, also confers the power to wait, if you want. Strong didn't eat the orange right then, so stuffed from the burger. He's not even sure exactly when he did. The holding of it, big as a softball, scored with wondrous dimples, was enough. When he finally did peel it and eat it, he said, it was juicy and sticky and sweet—an ordinary orange, in other words, and therefore unforgettable. —KJ

I found myself frozen in place after reading, in an interview in collaboration with The Center on Wrongful Convictions at Northwestern University, Strong's responses about his post-prison meal—how he'd been handed an orange, a beloved fruit that he'd been denied in prison for many years.

I know how to paint an orange. I don't know how to paint not having an orange. I paced. I left town. Left my studio at Oregon State University's Center for the Humanities and spent ten days in Hailey, Idaho. Distance. Something else one doesn't get in prison. I walked alone and studied the clouds.

Back on campus, I painted a facsimile of the interview, a hand holding an orange. An idyllic setting, the Illinois state bird and state flower on the border. Paint application is sparse. But still I couldn't be sure: How do you depict absence? How do you depict loss? —JG

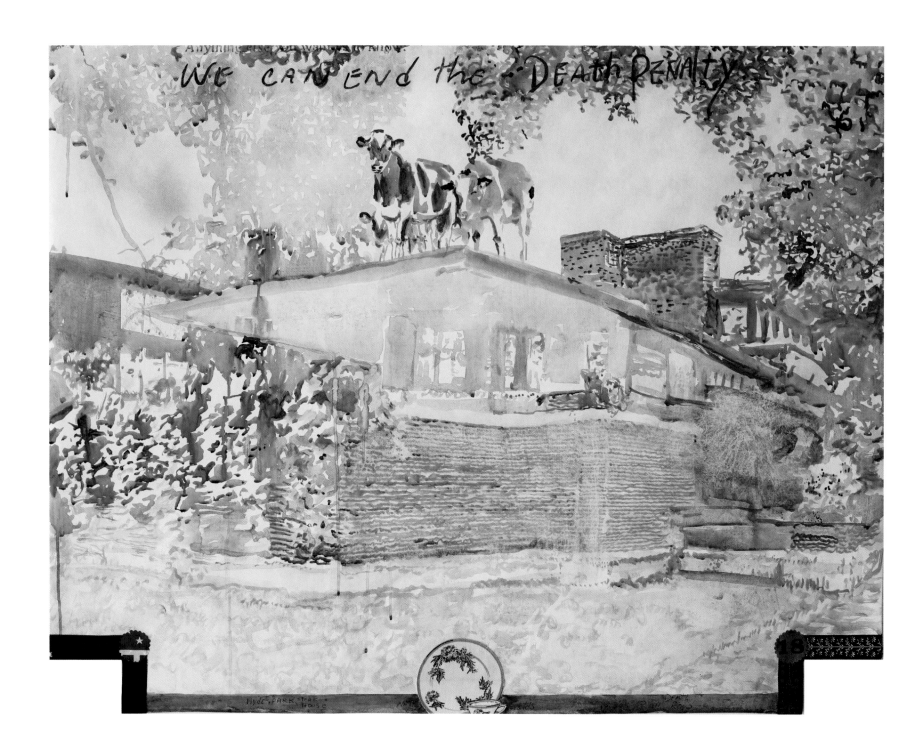

Hyde Park Steak House

In the company of news media and family, Nate Fields and a fellow exoneree, Aaron Patterson, ate steak. Their first steak in a long time, at Hyde Park Steak House. Taking liberties, I depicted Hyde Park's landmark Robie House by Frank Lloyd Wright and added a few cattle to the roof.

Many years ago, I saw a genius monologue by the actor and writer Spalding Gray, describing a badly faltering interview he'd once done in front of a live audience. Gray couldn't seem to find the narrative, the spark. Finally, trying to wrap it up, he asked the woman he was interviewing: "Is there anything else you want us to know?" The woman paused, sat up straight, looked out at the full house and said, "Yes. To the women in the audience, it's not your fault if it rains at a picnic."

Those words were a revelation. Oh! We are not in control of the weather. We are not in control of so many things. Spalding Gray's Hail Mary question, and the stunning answer that came from it, opened up the interview to a universe of new depths and possibilities. Since then, talking to friends, students, family, doctors, exonerees, I often ask a version of Gray's question, hoping for more revelation and sometimes getting it. When Karen Daniel and I worked together on the interview form for first meal stories we thought this was an important question to ask. *Anything else you want us to know?*

When Nate Fields was asked that, he wrote in big bold letters: WE CAN END THE DEATH PENALTY. —JG

2021
38 x 49.5 in.
acrylic, cotton, nylon star and number cut from Illinois state flag, hundred-year-old silk ribbon from Green's grandmother, thread and glow-in-the-dark paint on Tyvek

In his black robes, with his grey hair swept back majestically over a high forehead, Judge Thomas J. Maloney certainly looked the part. It was easy to see him as the real thing, out to administer impartial justice without fear or favor. The truth only came later, that he was a con man, probably scanning the courtroom from his high-perch wooden bench for the next bribe.

Fields was easy to stereotype too. He was a member of a Chicago street gang called El Rukn in the mid-1980s, a time when Chicago and other cities felt out of control. Gang members were easy to blame for the city's undertow of crime and murder, and juries were easy to convince when a gang member was brought before them.

Wrongful convictions can happen for many reasons, from innocent eyewitness error to deliberate disregard of law and evidence. Then there's plain old greed and corruption. And in the swamp of Maloney's courtroom, which Fields entered for his no-jury bench trial in 1986, accused of the double murder of two rival gang members, hardly anything was what it seemed. The FBI was watching Maloney by that point, court records later showed, and Maloney had apparently gotten wise to it. He'd taken a $10,000 bribe to fix the case—a felony for which he was later convicted—from a lawyer for one of Field's codefendants, Earl Hawkins. Sensing the heat and wanting to look tough, the judge returned the bribe money, convicted both Fields and Hawkins of murder, and sentenced both to death.

Meanwhile, investigators had cooked the case from the other side, with ample proof, an appeals court later said, that incriminating evidence against the defendants had been concocted, and favorable evidence concealed. Witnesses mysteriously turned up who, it later turned out, had had no real opportunity to see the supposed perpetrators. A police lineup that included Fields was created "more or less out of the air," a court said.

And then, through Fields's long journey back from death row, a third wrinkle emerged, as he and his defense team learned that Chicago law-enforcement authorities had a practice of keeping what were called "street files" in criminal cases. Street files contained potentially helpful information to defendants that, in violation of the US Constitution, had been concealed and hidden.

More thirty years after his conviction, a jury ordered Chicago to pay Fields $22 million in compensation for the wrongs done against him, and a federal judge then tacked on another $5.6 million, ordering the city to pay Fields's legal bills too. Chicago appealed the ruling, but a three-judge panel said the revelation of the street files had established Fields's claims of harm. "The evidence presented in this case—that such street files were still being used and that exculpatory evidence from such files was still being withheld in criminal cases—allowed a jury to conclude that the city had failed to take the necessary steps to address that unconstitutional practice. Accordingly, the district court did not err in determining that there was a legally sufficient evidentiary basis for a reasonable jury to find for Fields," the court said.

Judge Maloney was ultimately convicted of racketeering and other corruption charges, despite his claims, apparently made with a straight face, that prosecutors in his case had withheld valuable information from his defense that would have cleared him. In 1993, a jury determined that Maloney had taken more than $100,000 to fix cases, and a judge sentenced him to fifteen years in prison, of which he ultimately served a little more than twelve. On his release, he once again declared his innocence and blamed "overreaching" prosecutors and "scumbag" witnesses for his downfall.

Fields's journey through the system revealed an astonishing trail of rot and ruin. But his legal victories also showed that the system, however much it sometimes fails, is also capable of taking a hard look at itself, and that in opening files that were shrouded in darkness, knowledge is power.—**KJ**

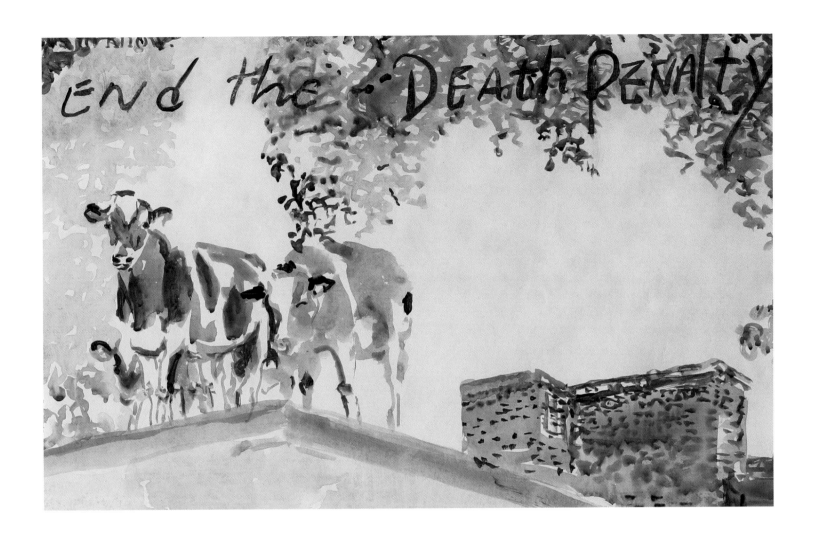

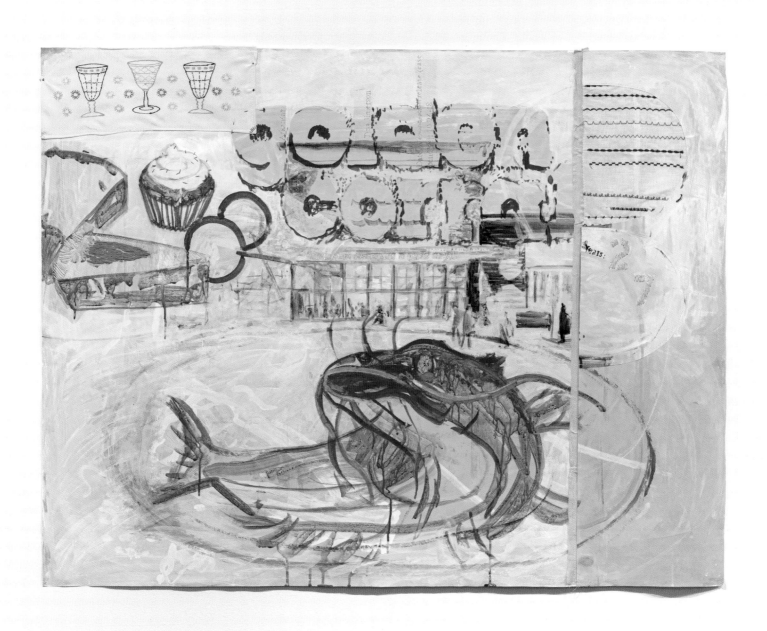

Golden Corral: Everyone Deserves a Good Meal

11

The Golden Corral restaurant chain's slogan is "Everyone Deserves a Good Meal." They do. I wish this was true in prison, after prison, and for all people. Karen Daniel, then a nationally known attorney leading the Center on Wrongful Convictions at Northwestern's Pritzker School of Law, attended this exoneree's first meal at Golden Corral's endless buffet. A few hours later, Daniel excitedly emailed photos that made me feel like I was there celebrating, eating catfish, piling into the desserts.

This piece is the first mixed medium in the series. The art of Clay Lohmann, my husband of three decades, inspired me to add fabric, to sew and embroider "27 years." The festive tea towel (upper left) was embroidered by my grandmother. *Everyone Deserves a Good Meal* is in glow-in-the-dark paint, which captured for me the idea that what is hidden in darkness must be seen. —JG

2019
36 x 47 in.
acrylic, glow-in-the-dark thread and paint, silk thread, vintage piecework, and one silver bead for fish eye, on Tyvek
Collection of Jaune Quick-to-See Smith

The Golden Corral experience is all about choice. Pile it on if you want, or spoon out just the tiniest portion for a taste. Have dessert first, or only dessert. Eat macaroni and cheese topped with cornbread stuffing and bacon. It's your call, which surely must be an intoxicating and powerful sensation for an exoneree fresh out of prison.

Every criminal prosecution is also in some ways a buffet, in finding and prioritizing the available evidence. And in the case of this anonymous exoneree, police and prosecutors made a crucial, devastating choice. They enlisted a compliant jailhouse informant, hooked him up with a recording device, and urged him to have a chat with his cellmate about a crime they were trying to solve.

They didn't say anything to the defense about any of this, and the recordings were subsequently lost, making it impossible to prove one way or another what those little chats really revealed. A federal appeals court, ruling twenty-eight years after conviction, said that law enforcement's conduct, including the

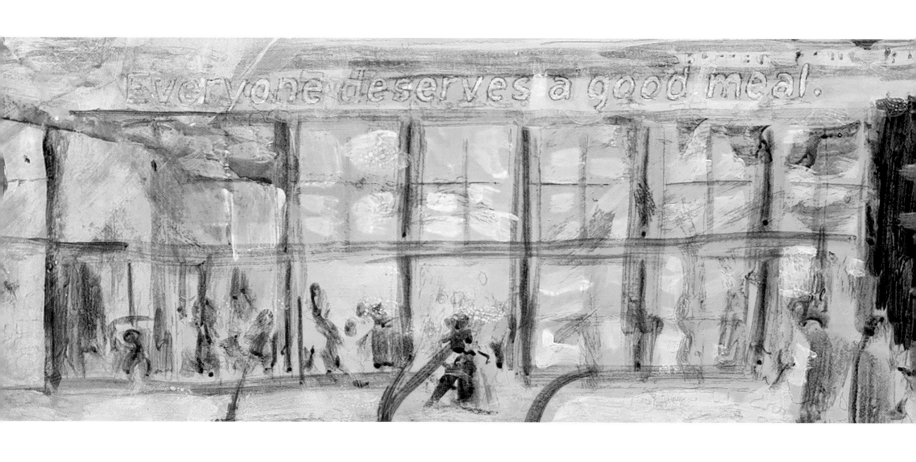

convenient loss of the recordings, showed "uncontroverted" evidence of bad faith and "a conscious effort to suppress evidence."

Jailhouse informants are often offered inducements for their help in gathering dirt on other inmates. In this instance the authorities were trying to solve a brutal rape and murder case. The motivation to find and punish a monster is understandable and proper. But when law enforcement dangles a reward to people who are in many cases on shaky ground with the truth to start with—assuming, of course, they did indeed commit the crime that got them in jail—the information that comes back is often exactly what prosecutors want and expect. A snitch has every incentive to lie to please his handlers and few reasons not to.

To a jury, jailhouse testimony probably sounds genuine. A conversation in a cell or a corner of the recreation yard comes from an environment where people are presumed to be filled with remorse and guilt over their crimes, just waiting to spill their guts with dark admissions. So when the prosecutor says, "Ladies and gentlemen of the jury, here's that very person, the one who heard those whispered secrets with his own ears! He'll tell you all about it," it's hard to ignore. Meanwhile, the details of the informant's sweetheart deal go undisclosed, and jurors are forced to make decisions based on incomplete information. Had they been told what the snitch received for his testimony, they might have rejected it or given it less weight in their deliberations.

The National Registry of Exonerations stated in a 2015 study that of 1,567 wrongful convictions it had tracked to that date, one in twelve had come at least in part from jailhouse informant testimony; in murder cases, the figure was closer to one in six. There are a few threads of hope, however. Since 2000, courts and legislatures in at least seven states have imposed limits on the use of informant testimony. Some now require pretrial hearings to assess an informant's reliability, or disclosure of the benefits informants received in return for their cooperation. Others now mandate corroboration from other witnesses to substantiate what an informant has said.

Simple honesty is where it should go from there: jurors should know who has an incentive to lie. And they should demand such transparency even in states where it's not required. How and under what terms was this testimony obtained? Lay it out and let the consequences roll. —KJ

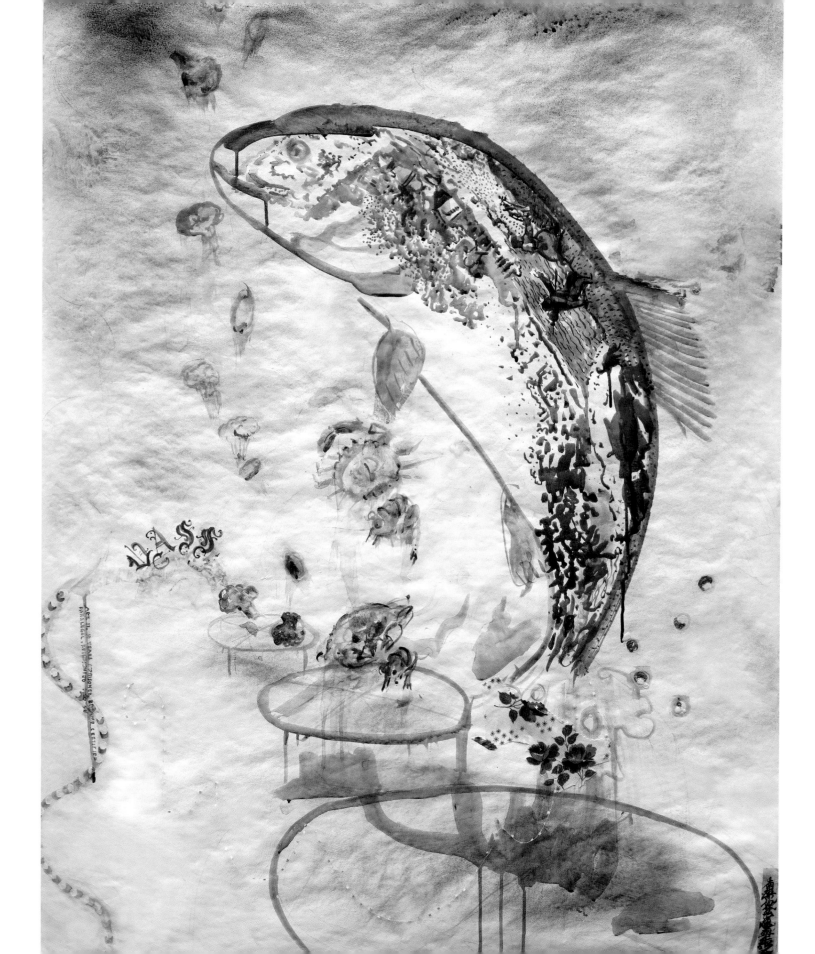

Mom's Rainbow Trout

For his first meal, Leslie Vass had his mother's home-cooked shrimp, rainbow trout, jumbo lump crab cakes, California medley vegetables, and brown rice.

I found items in our small back garden that seemed to belong on the painting, in that family scene. First, the broad, bright yellow feather from a bird I have not seen in Oregon. Then, Buddha's signature—it means protection—in ink on mulberry paper, laminated, smaller than a playing card. I thought about that as I attached it to the lower right corner: "Who needs protection more than a wrongfully convicted person?"

In Vass's meal, seafood and vegetables jump on trampolines. This is what painting allows. —JG

Vass stopped by his old high school in South Baltimore after his release from prison. He'd been a star basketball player there as a senior in 1974, a six-foot, seven-inch forward/center who was being recruited by big-name colleges—USC, North Carolina State, Virginia State—and had dreams of a life in the pros. Southern High School was gone, turned into apartments. One more thing that had disappeared without explanation.

"People's lives had changed, people's attitudes, and it wasn't like I understood a lot about the changes that had happened," Vass told me.

Moving forward after any kind of imprisonment is difficult. If the incarceration was unjust, it's harder still, trying to make sense of what happened, what you missed, what possibility there might be to catch up.

"It doesn't just end," said Jon Eldan, the founder and executive director of a nonprofit group called After Innocence, which provides long-term assistance and support to wrongfully convicted people. Eldan left behind a lucrative career as a corporate lawyer to work on the consequences of injustice. "Grappling with the lost time is a massive thing," he told me. "And they all do this in very

2021
49 x 38.2 in.
acrylic, fabric, thread,
found laminated prayer,
palladium and glow-in-
the-dark paint
on Tyvek

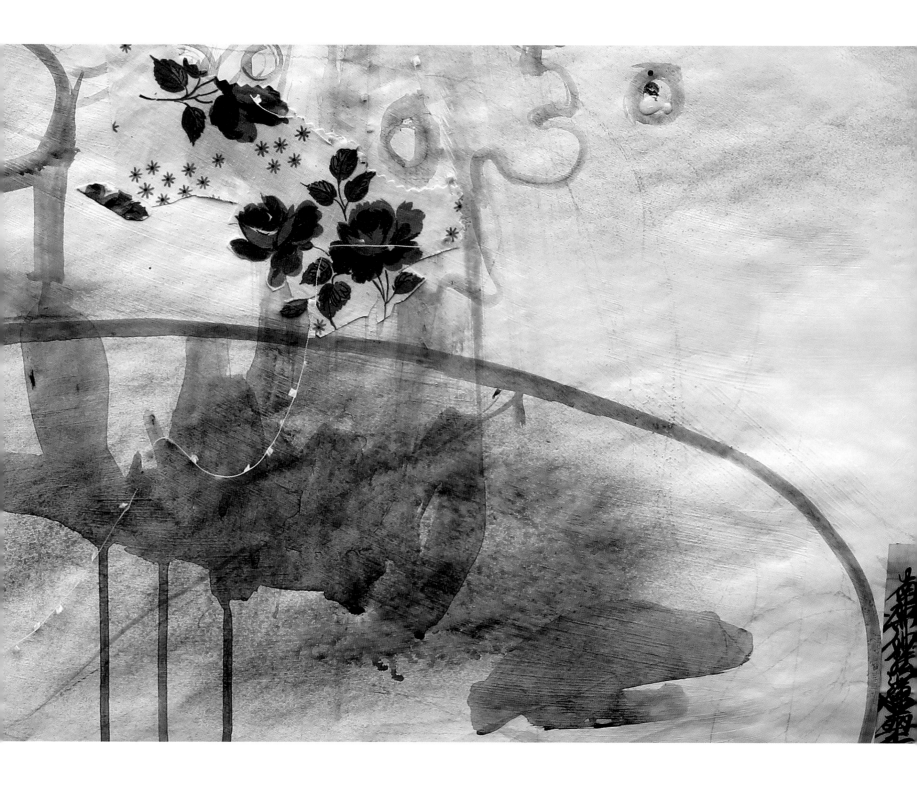

different and personal ways, most of which are not even visible. How do you deal with the fact that a lot of the things that you wanted for yourself or imagined were basically put on ice?"

People do grow and change in prison. Sometimes they even emerge stronger, in ways they couldn't have imagined or predicted. Some find faith. Kristine Bunch from the first chapter, along with Jason Strong from chapter 9 and Fernando Bermudez, chapter 17, emerged full of commitment to change the criminal justice system and help other wrongfully convicted people. Huwe Burton, chapter 18, became a runner on the prison track, and an acomplished musician in his cell.

But the path after prison, back into a world that has moved on to a new place, is precarious.

"I always say that half the battle is getting them out," said Jennifer Blagg, a defense attorney who has worked on many wrongful conviction cases. "The other half is trying to see if they're a happy person after they get out. Are they going to adjust to society and be happy?"

Blagg has had clients who won exoneration only to find themselves depressed to the point of suicide, feeling lost. One man she represented called her as she was vacationing in Michigan, telling her that he was about to jump off a bridge.

"The battle is never over," she said.

Nor is the learning curve, exonerees and their advocates say. Applying for a driver's license, health insurance, or a job means negotiating technology that in many cases has changed profoundly during those years locked away. Struggling with tasks that other people take for granted creates yet another barrier to reentry into society.

At After Innocence, Eldan said the effort on behalf of exonerees right out of prison comes down to the basics. First, have you got identification? "We're not going to just send you to a website," he said. "We're going to be your one-on-one, on-the-phone companion, walking that path until you get that photo ID, which is maddeningly complicated." Next, is an exoneree eligible for government aid? Eldan's group will walk people through the application processes and requirements. If a person needs a lawyer in some specialty like real estate or family law, he or she can call for a referral. Dental care? An arrangement worked out by After Innocence with a big health care provider allows exonerees to visit dentists free of charge in some states.

When I talk with Vass, he tells me about his journey after prison in a deep, quiet voice, how he returned home to Baltimore after serving ten years for an

armed robbery he didn't commit, and how bewildering it all was, searching for stability on a landscape that had changed. He was homeless for a time, living in a borrowed trailer. In February 2020, just as the COVID-19 pandemic was unfolding, he got stranded for four days in Santa Rosa, New Mexico—speck of a town halfway between Tucumcari and Albuquerque—when the head gasket blew out on his car as he was driving back from California. He'd lost a job in California, he said, because a records glitch in the state corrections system turned up his conviction, which should have been expunged, but was not. And

so the consequences continued to ripple through time and space. A mistaken witness identification and an inadequate legal defense put him in prison; a failure of bureaucracy then hit him again after he'd been cleared. More than four decades after his conviction in 1975, when he might have been starting for a Big Ten team, Vass was still fighting the malignant ghosts of his past.

> That's the part that I feel is the real injustice about this. To be in prison from the age of seventeen to twenty-eight, to take from me everything that I thought that I was going to have opportunities to do as a youth who was playing basketball in high school, with high expectations of moving forward, and to have that career path then snatched away from me. And then I finally make it back into society and still have to be labeled with the crime that the state admitted I did not commit. To me, that was a tragedy in itself. My conviction took from me something that I lived for. All I wanted to do was play ball—I played ball morning, noon, and night.

When he got out, it was a given that Vass's first meal would be fish. He'd grown up with the bounty of Chesapeake Bay in his backyard. Seafood represented home. And he'd come to think of fish like trout as symbolic too, always moving forward in life, swimming toward something, a future they couldn't see or imagine. It was a philosophy that he embraced as a survival strategy in prison, and in life after coming out. Trout demanded a place on the plate.

"They don't go back, and they swim forward, and that's what you have to do, you have to take that mindset and move forward," he said. I spoke with Vass by telephone in the summer of 2021. He was sixty-three, and like many big men, has had both knees replaced. Even his height, once an element of athletic promise, had become a burden in the twilight of his exoneration. Financially strapped, he was renting a basement apartment with a low ceiling. "My head touches the ceiling," he said. "Every time I stand up, I have to duck and bend."

He paused briefly. But difficulties are just part of life, he said. They don't, in the end, define a life. "These are the circumstances that we are faced with, and it's what we do with those things that generates who we really are," Vass said. "You have to keep moving forward." —KJ

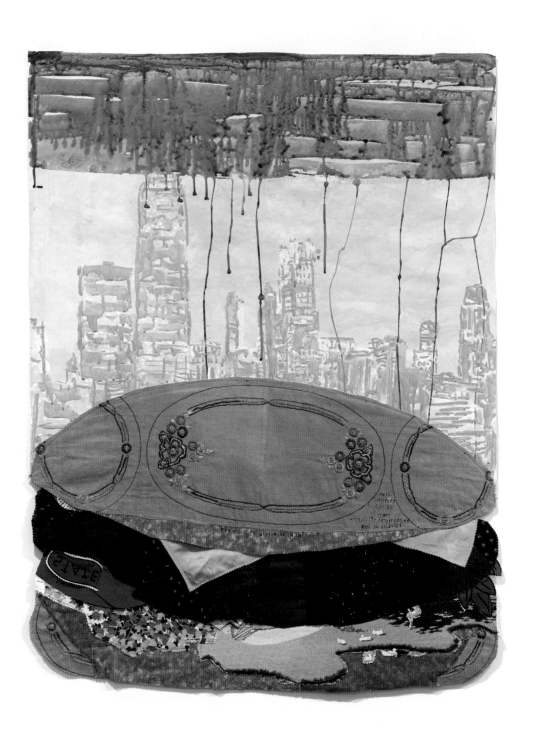

Burger Downtown for Mark Clements

It's a hard word to say, for all that it evokes: torture. But it exists, wound up inside human history and human nature, ready to emerge whenever conditions are ripe for it. We allow torture, or look the other way when it happens, for different reasons at different times. When ancient Romans gathered at the Colosseum in the tens of thousands to watch people being killed in terrible ways, it was deemed entertainment, or perhaps education, an edifying study of the human spirit in duress. When executions are held in public, some say it is to discourage crime. After 9/11, the excuse for torture was that the threat of terrorism demanded a harsh response in the name of national defense. Pick your rationalization.

Torture to make people talk is famously unlikely to result in truth, as psychologists realized long ago. At a certain point, people will simply say whatever is wanted. Yes, I admit to being a witch, or a secret Jew, or a Communist. You want me to confess that I'm a Martian, here on earth as the advance scout of an interplanetary invasion? Yes, absolutely. That's also why the most successful underground cells, like the Maquis in the French Resistance during World War II, were so hard for the torturers of the German Gestapo to crack. They didn't have many names to give up because the system was specifically structured around keeping operatives in the dark about who else was in the fight. But the core impulse that torture ultimately boils down to is power. The inflictor of pain—through sadism, zealotry, or insecurity—seeks control of another person.

In Chicago, from 1973 to 1991, at least fifty-seven people—and probably far more than that—were tortured while in the custody of a police commander named Jon Burge, or officers under his supervision. The crimes took place at Area Two Police Headquarters and later Area Three Police Headquarters, according to court records. In 2016, the city of Chicago agreed to pay $5.5 million to those fifty-seven victims of Burge and what was called his "Midnight Crew" of like-minded officers.

2019
47 x 36 in.
acrylic, found fabric,
sewing, cut-up state flag,
and glow-in-the-dark
paint on Tyvek
Private Collection

Mark Clements was a victim of the crew. Clements, who was sixteen at the time of his arrest, reported that one of Burge's officers beat him with his fists, then squeezed his testicles, then beat him again, all the while insisting on a signed confession to arson for a fire in June 1981 that killed four people. Clements said he finally signed to make the pain stop, and the confession then led to four consecutive life sentences with no possibility of parole.

In an opinion issued in January 2020 in a case against Burge, United States District Court Judge Harry D. Leinenweber said that Burge's abuses were both ghastly and systematic.

"There can be no doubt that Burge was at the helm of a vast and vicious torture regime, or that Burge and his subordinates regularly committed horrific abuses of power to extract confessions from the people in their custody," Judge Leinenweber wrote.

What kind of torturer was Burge? By the accounts of his victims and the attorneys who investigated him, he seems to have genuinely believed that pain would produce truth. He also thought that brutality, and perhaps even more crucially, a *reputation* for brutality, would make society safer by instilling fear in the community he was responsible for policing. He seems to have reveled in the process of it too, wanting to teach others how to get results.

Andrea Lyon, a defense attorney in Illinois, led the team that ultimately took Burge down. A favored technique, she said, which Burge reportedly learned as a soldier in Vietnam, was to attach alligator clips, wired to a hand-crank generator called a "black box," to earlobes and genitals.

Keith Walker was among those subjected to the black box treatment, a process that led him to make a false confession to murder in 1991. In his trial, he told the court that he was tortured and sought to have the confession thrown out on that basis. But officers denied doing anything wrong and were believed, and the judge who was presiding over the nonjury bench trial sided with the officers. Walker's conviction was only vacated in 2020, after thirty years behind bars. The lawsuit filed after his release said that Burge and other members of the Midnight Crew applied whatever it took.

"These defendants tortured Walker, attacking him, kicking him, delivering blows to his head, choking him, and administering electrical shocks, among other illegal acts of physical violence," the suit says. Walker was awarded $256,000 by a state court in 2022.

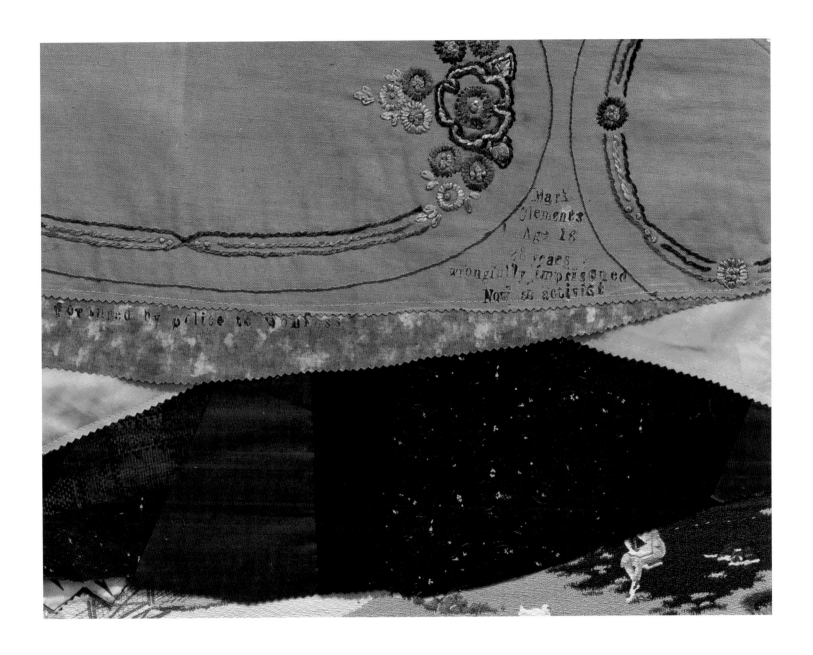

Mark
Clements
Age 16

28 years
wrongfully imprisoned
Now an activist

forbidden by police to confess

As for Burge, he was ultimately fired and later sentenced to prison himself, for perjury, essentially for denying under oath that he was a torturer, long after the facts of it had been established. Some officers in the Chicago Police Department, to their credit, provided anonymous tips that helped end the Burge reign. But many others looked the other way.

"It's that whole thing that we have as Americans, that we love the vigilante—the person who says, 'The hell with law, I'm going to make sure that the right thing happens,'" Lyon said.

And so, for a while at least, Burge attained a kind of hero status. "There were fundraisers given for him at the police department when he was getting in trouble and was having to defend himself," Lyon said. "It was amazing how many people thought the end justifies the means."

Clements served twenty-eight years in prison before his conviction was overturned. The torture that Burge initiated went on, and on .—KJ

Reading this case, I became angry. I cut up the Illinois flag, and it felt good to make it into a tomato. A vintage cotton print became lettuce. In a nod to historical flow-blue ceramics, the clouds are weeping.

Other things just had to shout: Hamburger. Downtown. Glow-in-the-dark paint for the Chicago skyline and for text about former police commander Jon Burge. It bears repeating again, shouting again, that Clements was only sixteen when the Midnight Crew got their hands on him. —JG

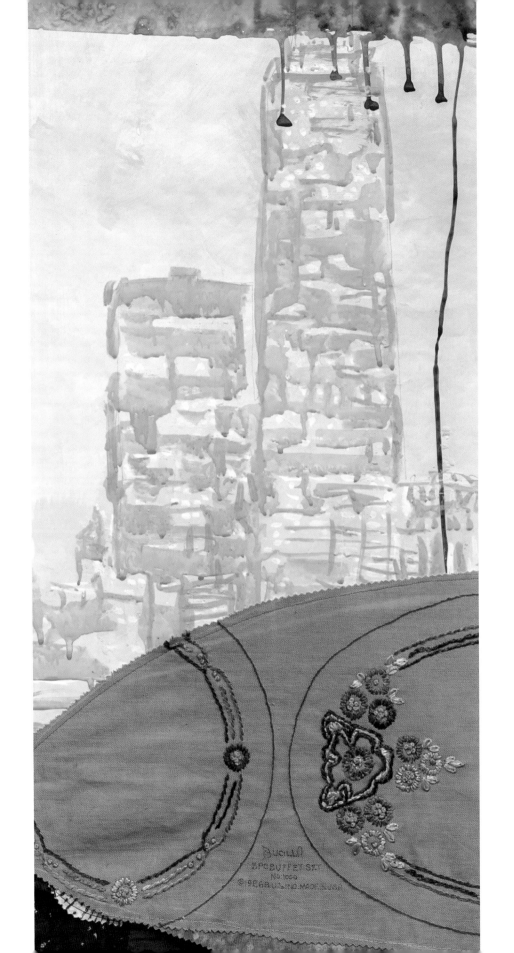

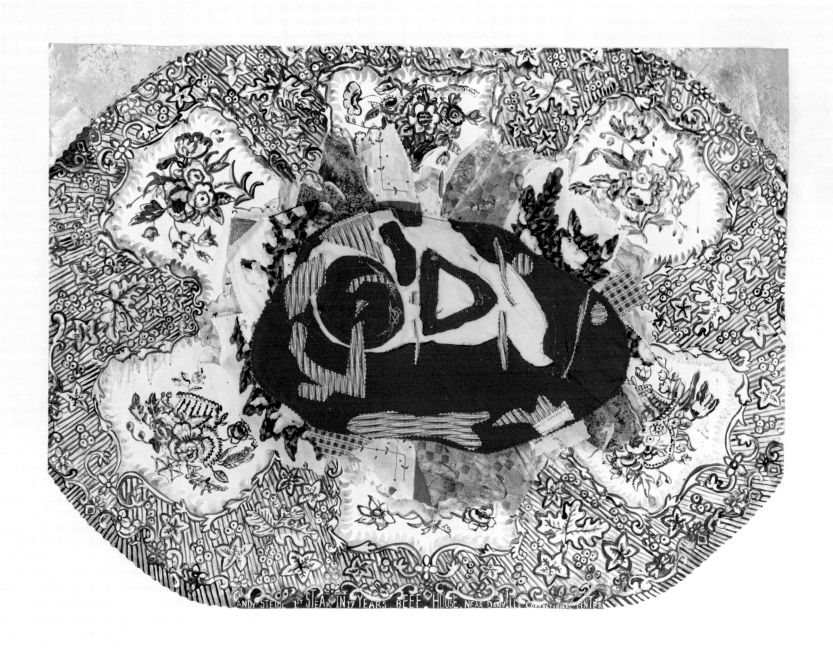

Beef House Near Danville

The painted text reads "Randy Steidl, first steak in seventeen years, Beef House near Danville Correctional Center." When a specific restaurant is mentioned in an exoneree's questionnaire response, I research interior, exterior, menu design, and the food served. Dozens of large, festive blue and white Spode platters line the walls of Beef House. They are the décor. Those colors and textures speak to me of home—Spode and flow-blue dishes have graced our table and influenced my work for decades. They also speak to the question of what makes art and who labels it. In this country, most historical ceramics and textiles are functional or decorative, and in college, I was told ceramics were not considered high art, but "just craft." That was enough to encourage me to examine the medium more deeply. Real art can be hidden in plain sight. Here, a Spode platter holds the meat. —JG

2020
36 x 48.8 in.
acrylic, palladium leaf,
fabric collaboration with
Clay Lohmann, glow-in-the-dark
on Tyvek

The rural Midwest is a distinctive place in geography and culture, and in the rhythms of small-town agriculture and farming derived from its deep black soils. Randy Steidl's story unfolded there. It's about an hour's drive from the tiny community of Paris, Illinois—population, 8,200—where Karen and Dyke Rhoads were found, stabbed to death, in their home in July 1986 to the Danville Correctional Center, from which Steidl was released in 2004 after sixteen years behind bars after his wrongful conviction. From Danville to Covington, Indiana—population 2,500—where he ate steak at Beef House Restaurant and Dinner Theater is barely ten minutes.

Paris, Danville, and Covington. Dots that Americans drive through or fly over. Places where farm and feed stores are social and economic hubs. Where murders are rare and profoundly shocking when they happen. Where family-owned businesses like Beef House can thrive for generations. Where you can drive through whole counties and never encounter a traffic light.

The Rhoads were newlyweds, married barely a year, both in their twenties. A firefighting crew found their house in flames. Inside, their charred bodies had each been stabbed dozens of times. It was a horror story that played out in Illinois media like an echo of Truman Capote's *In Cold Blood*, which told the story of the Clutters, a farm family murdered in their home in Kansas in 1959.

Two of the prosecution witnesses against Steidl, a thirty-five-year-old construction worker at the time of his arrest, were shaky from the beginning. One later recanted her testimony, then disavowed her recantation. One claimed to have seen a broken lamp in the Rhoads house that was used to beat the victims—a powerful visual image that came up over and over in the prosecution's case as a symbol of the savagery unfolding inside the Rhoads household. Years later, investigators concluded that the lamp was broken by firefighters as they rushed in to fight the blaze. Steidl was sentenced to death. A codefendant, Herb Whitlock, got life in prison.

A crime in a rural town had brought out the best and the worst in the people who were touched by it.

The Beef House, by contrast, at the other end of Steidl's journey through American injustice, is all about pride, tradition, and continuity, which are also hallmarks of a region of the country I've visited many times and come to love. Businesses that stay in a family for generations are like that. They come to feel almost sacred to customers, and family members too—stuffed with old bits of lore about how things came to be, mistakes still chuckled over decades later, triumphs, accidents, and tight scrapes when the economic future looked grim.

And the name says it, too: beef. Right there as you come in, slabs of it, deep red and marbled with fat. It's not hiding back in the kitchen. Bob Wright wants you to see the star attraction and smell it first thing.

"When you walk in the door, we have a meat case and we cut all the steaks every day," said Wright, who grew up in the restaurant, founded by his family in 1964.

At Beef House, the dinner rolls are stars, alongside the rib eyes. They trace back to Purdue University near Indianapolis, where Wright was a student in the 1960s, studying hotel and restaurant management. To help pay for tuition, he worked in the school cafeteria, and fell in love with the dinner rolls they served. So, being a curious kitchen guy, he asked how they did it. What was the secret?

"Some of the older ladies showed me how," said Wright.

When he came back to Covington, he took the recipe he'd learned and began to play with it, gradually transforming a college cafeteria staple into a signature of Beef House cuisine, and beyond that a tradition in its own right in southern Indiana, especially around Thanksgiving. People come from many miles around to buy the rolls fresh, or frozen to cook at home, and have them on their table when families gather for the holidays. Local grocery stores, at that time of year especially, stock Beef House rolls for their customers.

"In November we sell about 60,000 dozen," he said. "About 80,000 pounds of flour a week comes through the kitchen to make it all happen."

Steidl's conviction was reversed in part through the effort of a team of journalism students at Northwestern University who re-examined the case in 1999 for a class project. In 2000, an Illinois State Police report, by one of its own, Lieutenant Michale Callahan, concluded that the convictions in the case "had not been proven beyond a reasonable doubt" and that another suspect "should still be the focus of the investigation."

Wright told me he didn't remember a man named Steidl coming to eat and celebrate with his lawyers on a day in late May 2004. It's a busy place and it was a long time ago. But no matter what, Wright said, Steidl would certainly have been served some rolls. —KJ

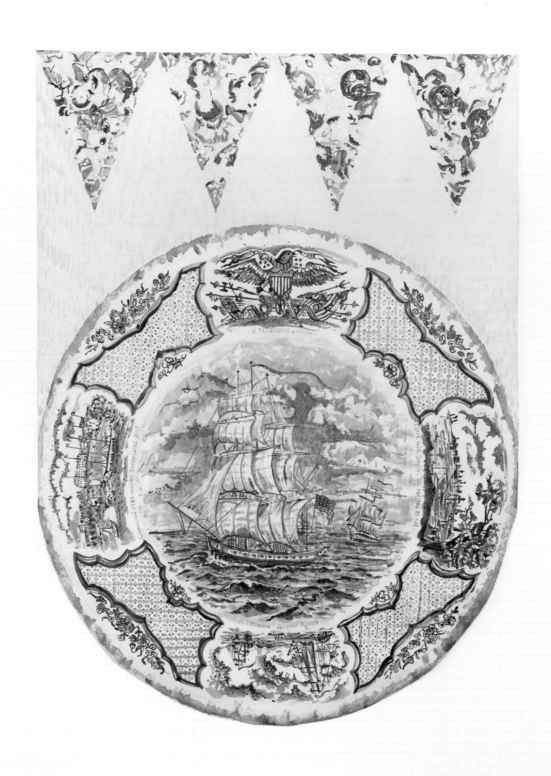

Pizza Pennant

2018
46 x 36 in.
acrylic on Tyvek
Cleveland Clinic Art
Collection (London)

This painting is heavy. Painted and sanded, back and forth, it is smooth but has more paint; it weighs twice as much as the others. I reworked it several times before making a banner of pizza slices across the top, which captured for me Jacques Rivera's meal with family and friends after serving twenty-two years for a murder he didn't commit. Rivera told me he was too excited to eat and very, very happy to be home. I embedded new text within, from the Great Seal of the United States: *e pluribus unum*, Latin for "out of many, one." One of many wrongful convictions.

It takes about three weeks to paint each *First Meal*. There is time for reflection. Painting can be a meditation. Here, painted pizza slices remind me of prayer flags. This led me to think of the entire series as flags, pennants, fluttering somewhere on a mountaintop, waiting to be *seen*. —JG

Rivera was fifteen years into his prison sentence and feeling like he'd run out of room. He remained adamant that he was only behind bars because he'd been framed—by the mistaken eyewitness account of a twelve-year-old boy and the manipulation of evidence by a rogue Chicago police detective named Reynaldo Guevara. But the appeals process seemed to have played out, and his assertions of innocence continued to fall on deaf ears. Then one day as he was working his prison job in the segregation unit, where inmates are held in solitary confinement around the clock, he saw something.

"In my peripheral vision on my right side, I saw an object underneath one of the doors, the rails that the doors run on," he said. "I was like, 'What is that over there?' The floors are waxed, they're shiny, you know, there's no garbage, nothing on the floor. We sweep and mop every day."

So he went over to investigate. It was a small metal cross, encrusted with dirt and lying there in the last place on earth he would ever expect to find it. "I cleaned it up and found an inscription," he said. "And it says, 'Christ has chosen you.'" Those were the very words that had been echoing in Rivera's head from a voice that came to him not long before that day in the middle of a prison church service.

> I heard this voice come to me and say, "My son, I am here for you. I have chosen you. You didn't choose me." I heard it. I heard it clear as day. I was looking around, like, did somebody say that, who said that?

Finding a cross had to have meaning, Rivera concluded. It was a sign. He'd arrived in prison angry—at the world in general and more specifically at the people who'd put him in there, knowing he was innocent. They were outside, living their lives and facing, so far as Rivera knew, no consequences for their actions. Surviving prison, though, meant putting all that aside—everything except what it took to stay alive and safe. "I had to focus on what I was going into. I had to focus on watching my back in a maximum-security prison, following the do's and don'ts," he said.

So the years went by, and Rivera's religious belief grew and deepened, fueled especially after the discovery of the cross that he believed had somehow— through ways and means that were beyond human understanding—been left there for him that day in the segregation unit. His path of faith was a source of comfort, but it came with demands for action too, he said.

Finding a way to forgive the mistaken twelve-year-old witness was the first. That one came quite easily. "I automatically forgave the kid because he was a kid. He didn't know no better," Rivera told me. But then the voice kept telling him that there was another to absolve, a harder one. And the voice kept nagging. "You know, that's got to go for Guevara too. And I was like, 'You want me to forgive Guevara?'" Rivera said. "'You know, he intentionally set out to do this.'"

Guevara's name was already becoming a dark legend of law enforcement by that point, with at least twenty bad cases and wrongful convictions eventually piling up—and legal settlement costs in the tens of millions of dollars paid out by his former employer, the city of Chicago. (More about Guevara in chapter 19.) But Rivera's inner voice wouldn't be still. "If you want to be forgiven, you have to forgive others."

E PLURIBUS UNUM

On the day of his release from prison in 2011, after Cook County prosecutors dismissed all the charges against Rivera, everything was swirling. Family members kept asking what he wanted, trying to heal him and bring him home with food and comfort. There was kindness and love in their questions, but it was all too much.

"What do you want to eat? You want something to eat? What do you want to eat?" Rivera said, recalling the day. "And I was just too overwhelmed with being out, and very nervous and paranoid. And I was like, 'Oh, whatever, whatever, whatever.' So my sister was just, 'Let's get us some pizza, let's start off with pizza,'" Rivera said. Pizza had sounded like a good idea but as a first meal, it didn't work. "I think I took a couple of bites out of it, man, but my stomach was in knots."

The next morning, he was at his mother's house and the knots were still twisting.

"Channel seven news is downstairs knocking on the door wanting to know what I ate for breakfast and how am I coping," he said. "And I'm like, 'These people are on my door first thing in the morning?'" Things eventually quieted down. His stomach settled. The reporters found another story to chase. "It took me a couple of days," he said. "But after that I was eating up a storm."

In 2018, a jury concluded that Guevara had indeed suppressed evidence that would have cleared Rivera, and ordered a payment of $17 million from the city of Chicago to compensate for the more than two decades stolen from his life. But the journey through prison into faith and the strength he'd found to forgive had made Rivera a far different person by then. He'd come to believe that God leaves clues and guidepost markers on the path, sometimes as hard to ignore as a voice that comes out of nowhere, other times easily missed, spotted only from the corner of your eye. All you can do, Rivera said, is be ready. —KJ

Convicted 1989 murder. Exonerated 2011

Pizza with family. Too excited to eat.

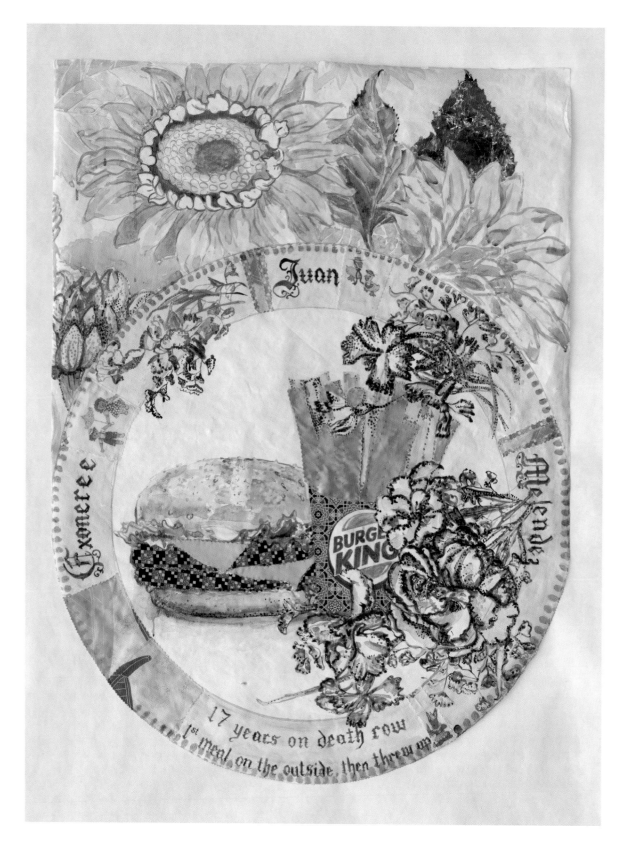

Juan

Exoneree

Melende

17 years on death row
1st meal on the outside, then threw up

Whopper, Fries, and Then

Juan Roberto Melendez gave a lecture in 2013 at Oregon State University, where he spoke of spending seventeen years on Florida's death row. The day of his release, Melendez said he was called by name, not a number, handed clothes and a few dollars, and taken to the open door where he walked out of prison alone. At the end of the talk, I asked about his first meal. Melendez loves burgers and had long been craving one. He ate a Burger King Whopper and fries, he said, and threw up. —JG

2020
48.5 x 36 in.
acrylic, palladium leaf,
silk, cotton, paper and
glow-in-the-dark paint
on Tyvek

In the hierarchy of a maximum-security prison, death row exists in its own special circle, a place set apart, where all are marked for death. And unlike the inmates serving regular sentences of years or months, the clock in a strange way also goes backward on death row—running not toward release, and how many months or years remain, but toward execution and the moment when the state, or the courts, say time has run out.

Death row's absolutism makes for a deeper level of certainty about guilt too. Defense attorneys say that it's harder to overcome a conviction that resulted in the death penalty, even when none of the evidence is true. Like a safe with two tumblers and locks, a death row inmate has not only been convicted of a terrible crime, but then, in what is usually a separate court proceeding, was found to have committed that crime in heinous or aggravating circumstances that demanded the most severe punishment.

On death row, everything—even by the standards of a maximum-security prison—is limited and constricted, as if to underscore the idea that a condemned person with only a limited time left to live just needs less or deserves less.

"They kept me in a six-by-nine-foot cell," Melendez said in an interview after his release. Death row inmates in Florida didn't get to experience the community of prison—no meals in the chow hall with the other inmates, no regular

opportunity for exercise, which for many an inmate is a precious means of holding onto sanity.

"We used to go to the recreation yard not that much, four hours a week. Two hours on Monday, two hours on Wednesday, if it don't rain. All they have to do is see a cloud in the sky and they say 'Inclement weather, today no yard,'" he said.

"Next to me is another person that I know for ten or fifteen years," Melendez recalled. "He cries on my shoulder, I cry on his. He shares with me his intimate thoughts, I share mine with him and grow to love him, and one day they snatch him out of the cell and I know what's going to happen. They're going to kill him."

Melendez was convicted of the murder of a man named Delbert Baker in Auburndale, Florida, and sentenced to death on September 20, 1984. His sentence was upheld by the Florida Supreme Court, but the transcript of a confession by another other man, Vernon James, was subsequently discovered. Melendez's lawyers found that James, who died before Melendez's release, made at least four confessions to investigators or lawyers, but was apparently never taken seriously.

Melendez was released in January 2002 after the exposure of a chain of errors and failures that kept the real killer from being brought to justice: witnesses who had grudges or mental health issues or simply wanted to curry favor with investigators; prosecutors who withheld evidence that might have cleared Melendez's name. Lawyers who work on capital cases say that while a systemic legal breakdown of the sort that happened to Melendez is not uncommon in wrongful convictions that result in a death sentence, there is often within that dynamic a tiny piece of evidence that emerges and makes the difference, or does not, as the clock ticks toward execution. Sometimes you find that piece in time, as Melendez and his team were fortunate enough to do, and sometimes you don't.

B. Michael Mears is haunted by a case where he lost that race with the clock. Mears, an associate professor at John Marshall Law School in Atlanta, has worked almost exclusively on death penalty cases—more than 160 of them—through a long legal career as a defense attorney.

"I spoke to my client, I guess, about two hours before he was executed in the electric chair. And he told me, he says, 'You know, I didn't do it. I didn't kill that girl,'" Mears said. "I thought I had plenty of evidence to prove that at the trial. I did the appeal. And I said, 'I'm sorry, I can't do anything else. The Supreme Court has turned down our request for a DNA test. And he said, 'Well, I know that.'" Mears paused for a moment in telling me the story. "And he actually went stoically to his death. But after that, going through the DA's file, we found a receipt."

The question of exactly when the victim died had never been established, and only when it was too late did truth emerge, that her death had come much later

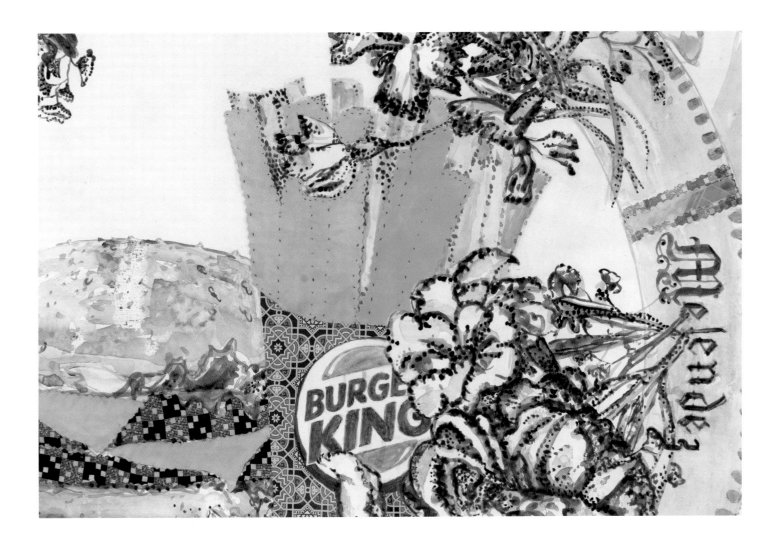

than the prosecution contended. "She bought a pair of shoes after our client had been arrested for her murder," Mears said. "She was alive when he was already in jail."

In an oral history of wrongful convictions published in 2005, Melendez said he experienced what felt like the end of his own hopes over and over. "Sometimes when you get an appeal and you lose your appeal, all your hope is gone. So you do like a little kid. When a little kid is trying to learn to walk, he falls, and when he falls, he cries and he's mad, but then he gets up and he tries to walk again. That's what I did," he said. "I'm probably the luckiest man in the world." —KJ

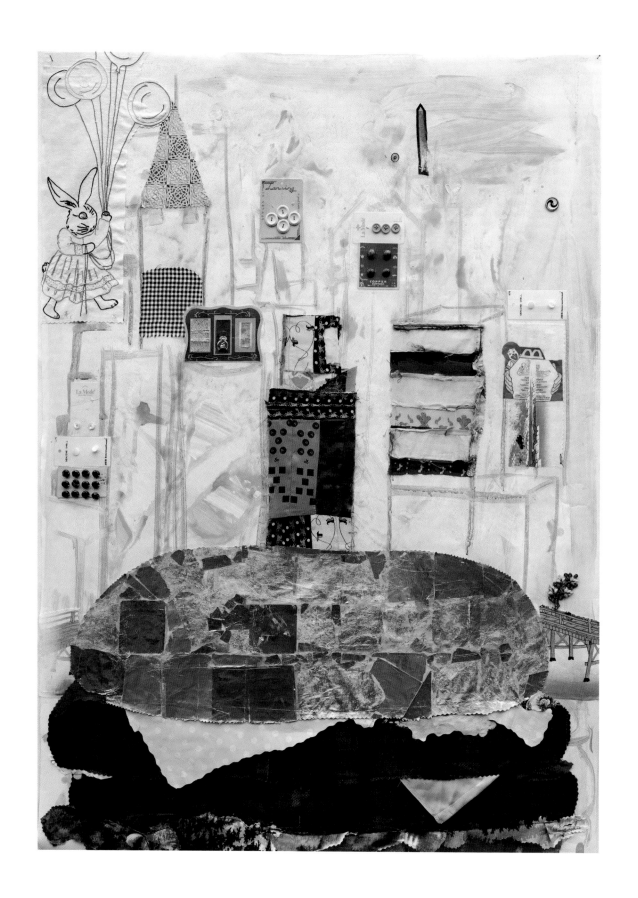

MacManhattanMom

My art focuses on marginalized individuals and communities—but also on contrast and choice. In this work, we see a burger bun where 24K gold lies next to metallic gold Trader Joe's Organic Dark Chocolate Truffle wrappers. Gold, false gold. Side by side, it's hard to tell which is which. Fernando Bermudez, a father and graffiti artist, writes of having "fast food en route from my Connecticut home to mother's Manhattan home where I would eat my first home-cooked, even bigger meal." Thinking of that meal, pulling out the stops, I used the good stuff. I opened my grandmother's big blue glass canning jar full of buttons, some a century old, with the price still marked: twelve blue glass buttons, twenty cents; a set of genuine pearl buttons, one dollar. Sewing, I created New York City, where Bermudez was shaped to be the man he is. —JG

2021
49 x 36 x .3 in.
acrylic, fabric, thread, 24K gold, metallic gold candy wrapper, vintage buttons and button cards, jewelry, and glow-in-the-dark paint on Tyvek

There are really three first meals to talk about in Bermudez's story. The fast-food buzz-in for a burger on the turnpike is one. The grand family gathering back in his old neighborhood in Manhattan is another. The third, he said, was in some ways the most meaningful of all.

It happened earlier, on a day in late 2009, after years of struggle to clear his name and prove his innocence of murder. He was in his cell at the Sing Sing Correctional Facility in upstate New York. A guard he'd gotten to know over his eighteen years in prison walked by. There was a slot in the cell for mail delivery, but the guard, it turned out, had just picked up a meal for himself from KFC. Fried chicken. And as he stepped to the mail slot, instead of a letter he dropped a chicken breast.

Bermudez was stunned—fearful, grateful, and ravenous all at once. The chicken smelled wonderful, but accepting it felt like an infraction. He grabbed it and turned off the light. "I squirreled it away, and there in the darkness where nobody could see me, I started eating it like I was some sort of, like, well, an animal," he said.

The chicken breast was a gift, a statement of kindness and support in a place where kindness was rare, a hint of the world that might be found outside prison if the last barriers to exoneration could be knocked down—as indeed they were, within a few months of that day. "It meant a lot to me," he said. "That gesture was really special."

Every life has its turns, the moments when we might dash on the rocks of disaster, or not, or when taking one road means forsaking all other roads. For the wrongfully convicted, those plot twists are lined with jagged cliffs. You're heading somewhere, maybe working toward a dream, maybe just being young, and then you're in darkness.

Bermudez was the oldest of five children, a son of immigrants who'd come to America from the Dominican Republic in the 1960s. In August 1991, he was twenty-one, enrolled at Bronx Community College for the fall semester, and excited to start school. He'd heard that nurses and physician's assistants had a potential for good wages upon graduation, so he was aiming for that. He'd absorbed a powerful work ethic, he said, from watching his father toil through a career in the parking garages of Manhattan.

Bermudez spoke to me in a Zoom conversation from Costa Rica. Tropical birds sang social declarations in the background. He leaned in close, his face filling the computer screen.

"He worked so long and hard in those dark parking garages," Bermudez said. "But I knew that I had a higher calling than just working in the parking garages, which is why I wanted to enter the medical profession." His little sister was six years old when he was arrested in 1991 and accused of a murder outside a New York City nightclub. Convicted in 1992, he was sentenced to twenty-three years to life.

His old road was gone, and a new one had to be built. He met and fell in love with his wife, Crystal, while still in prison. She'd heard of his fight for exoneration and wrote to him, starting the relationship as pen pals. After their marriage, he fathered three children with her through conjugal visits.

Since his release, Bermudez has given speeches about justice in multiple countries. He lectures in law school classes, talking about his journey, his struggle to grow and stay positive and how he held onto hope when appeal after appeal was failing. "My life has taken a higher meaning," he said. Whenever and wherever he speaks, his goal is always the same: "I want people to leave better than when they came." Making people more aware of wrongful conviction is part of that effort, he said, but he also sees hope for the justice system itself by the same mechanism: awareness.

The empirical evidence collected since DNA testing began—that is to say the over 2,700 exonerations since 1989—demonstrates that we have a severe problem. We can no longer say, as we did in the early 1990s, "Oh, it happens, you know, occasionally, a few bad apples." No, no, no. It's more than that. This is entrenched. This is systemic. A lot of people could not always say that before, back then.

He also wants his audiences to understand a truth he realized in prison, that however isolated he was, he was never really alone because he had faith in God, a community of supporters and family outside the prison walls, and perhaps occasionally even a small grace note of kindness in a place that had wrongfully locked him away.

The guard who gave him the chicken that day in his cell nodded as he walked past, Bermudez said. Just a little tip of the head. And something in that was as important as the greasy, delicious KFC morsel itself, maybe more so, Bermudez said. The nod said: I can see you, you're a human being, and you deserve this.

—KJ

PART THREE Strategies

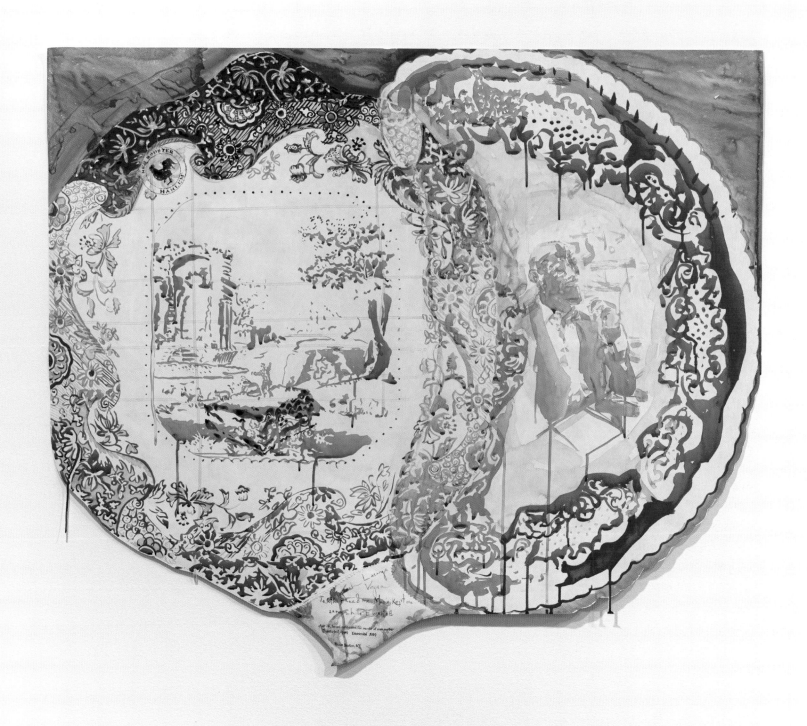

Huwe Burton Said Truth Freed Me, Music Kept Me Sane While I Waited

A digital print reproduction of each *First Meal* painting, along with a small honorarium, is sent to each exoneree in appreciation for their time and effort sharing their stories. At the same time, the correspondence over such things builds relationships. Working with Huwe Burton, it went like this, starting with the words he wrote—in beautiful handwriting—on the interview form about his meal: *"Truth Freed Me, Music Kept Me Sane While I Waited."* I made a facsimile of these words on the painting, then sent a print of the painting to Burton, who took a photo of the print hanging on his wall in New Jersey and emailed it to me in Oregon, and I posted it on Instagram.

So the circle expands.

In person and in correspondence with exonerees, I see grace, generosity, activism, and a surprising amount of optimism. In prison and on release surely there was anger and soul-searching. Surely there are hard days and nightmares when it all comes back. Even with music and art, being innocent in prison and staying sane is a tall order. Burton, whose image is included in the painting, is now a marathon runner, emcee, and public speaker. His father also had beautiful handwriting, and Burton said he sees penmanship as "a fingerprint to one's personality."

Such deep identity and insight bound up in those words. Who are we? Who am I? I'm just a painter. This is not my story. A curator once thanked me for my sacrifice and I said, "What sacrifice? It's not a sacrifice, it's an honor to do work that may incite conversation and change. I would be painting anyway." For his first meal, Burton ate vegan squash lasagna at the famous Red Rooster restaurant in Harlem. —JG

2019
40 x 47.3 in.
acrylic and glow-in-the-dark
paint on sewn Tyvek

Learning music theory, save for perhaps the most gifted of musical geniuses, is not easy or simple. What does the interval of a minor third really sound like and how do you hold it in your head, or a major fifth or—getting harder now—a

major thirteenth? And how do you imprint those chord intervals so that your fingers or your voice can find their way to the right place at the right time without conscious effort?

Each musical chord has empty spaces within it—notes that are played and notes that are not played. It also has a root note, the place toward which a musical phrase or progression of chords is always reaching, like the idea of home. What lives in those spaces, in the distance of one note to another? What worlds might be imagined and built in the through-line of a chord progression? All great music arises from these questions.

Now imagine that your course of music theory is not in some cozy conservatory, seated at the piano with your teacher, but rather conducted over the telephone inside a chaotic and dangerous prison.

Burton said he would try to hold everything in his head as he listened to his father, Raphael Burton, talk about the tonal landscape of intervals, scales, and chord structure. Then, as quickly as he could, he'd go back to the electric keyboard in his cell, where he'd try to reproduce everything his father had just taught him.

Raphael Burton, though mostly self-taught, had a deep well of musical knowledge. Born in Jamaica, he grew up steeped in the syncopations of ska, a precursor to reggae. The band he led and for which he played saxophone, Burton and the Sunsetters, toured Europe and elsewhere in the 1950s, spreading the sounds of the Caribbean long before Bob Marley. He came to America in 1970. Huwe was born in 1973. Music filled the house growing up.

> At sixteen, when this happened, I didn't realize how much music that I actually had in me all the time, ability that I had in me. I would have discovered it minus all of this, but the situation and the circumstance kind of brought that to light. At sixteen, I was just a kid who had dreams of selling out Madison Square Garden.

And at sixteen, all of those dreams roared away into horror. Burton's mother, Keziah Burton, was murdered, stabbed to death in the family's apartment in the Bronx. Huwe Burton found her body. The police became convinced he'd done it himself, and then tried to cover it up by arranging the body to make it look like a rape. His school incorrectly reported Burton absent that day, which gave detectives reason to question his alibi, and after many hours of interrogation, he signed a confession. A jury believed it and the judge gave him fifteen to life.

The school's error on the attendance sheets was found and corrected before the trial. But by then the confession was in hand and Burton's defense lawyer was never told that the school had called back. Years later, the confession was tossed out when evidence surfaced that the detectives who'd questioned Burton had a pattern of forcing false confessions from teenagers.

He spent eighteen years in prison, and through those years the phone conversations with his father became a lifeline—a running dialogue about beauty, self-discipline and family. "We could spend the whole click, you know, the duration that you have on the phone, just talking about music. And when he would come to visit, it was—after we got the pleasantries out of the way—like, 'Okay, well, did you practice today? What did you practice? Are you doing strength training?'" Burton said.

Burton learned, month-by-month and year-by-year, but he also found something else he hadn't expected—a new, deepened relationship with his father. Their musical conversations, he came to realize, had become crucial for both of them.

> It gave him a lot of strength to press on as well because his burdens and pains were double mine—to deal with the burden of losing your wife and your son and still have to be there, to live through it. It's like many parts of me feel worse for him than I even do for myself because of the weight that he had to carry. So for us to talk about music and to be able to get lost in the moment and just talk about music and the beauty of learning scales and what they would do for your music . . . we would just go into this for hours. And I started to notice and realize that it was adding a lot of years to his life, and the quality of his life, because his son really got it.

Burton asked for permission to speak to his father during the police interrogation. The request was denied. Raphael Burton was at the same time desperately trying to reach his son. He died at age eighty-three while Huwe Burton was still in prison. —KJ

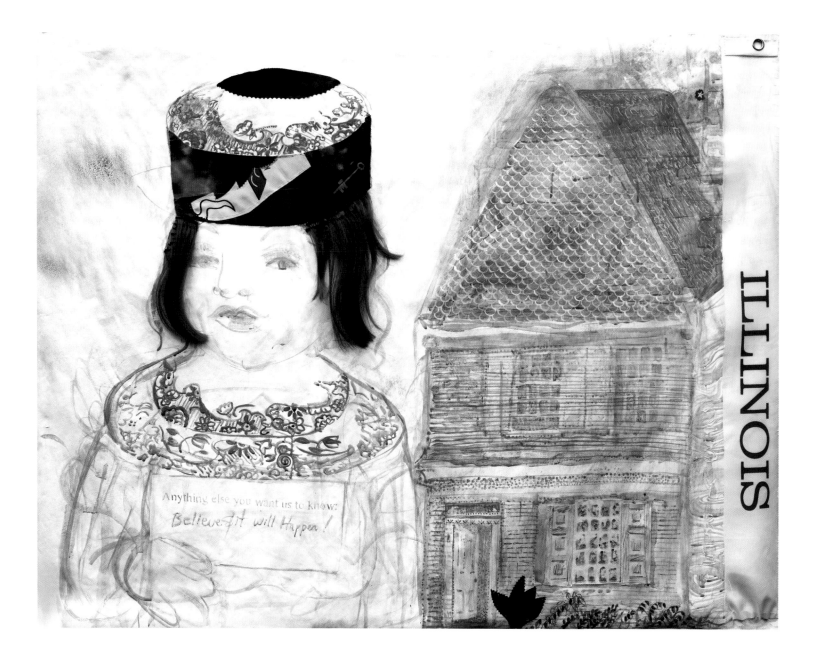

Anything else you want us to know:
Believe & It will Happen!

ILLINOIS

Aunt's House

I frequently mention my artist husband, Clay Lohmann, but the impact Clay has had on my art and life cannot be overstated. We discuss art daily, a fabric that runs through our lives. For decades, when asked, Clay would look at each painting and plate I made and offer suggestions.

Before starting this painting, we talked about using a photographic reference versus painting from memory; we agreed, as we so often do, that working from memory has more soul, more depth, more truth even if what is represented doesn't match any literal visual record. What's beneath the literal is what I seek, so each food story informs my process, palette, style, format. And like the exonerees, each painting must be unique.

On release, Roberto Almodovar had home cooking at an aunt's house. I imagined and painted a blue and white porcelain doll, female. The aunt. The aunt is holding a card with the exoneree's words: "Believe and it will happen!" The aunt, in my nonphotographic vision, has blue hair and I wondered how to render hair. Then I remembered the blue wig that Clay and I had in the basement, never worn. Wigs are amazing constructions. The underside looks like a corset with complex lace grids holding it together even after being cut into sections. Bodacious, said Clay, seeing blue hair firmly attached.

In the studio we are free. We can make anything we want. This is the best part of being an artist. Almodovar's term of wrongful confinement, twenty-three years, must be literal and loud, recorded in glow-in-the-dark paint. —JG

2021
49 x 38.5 in.
acrylic, Illinois state flag and other fabric, blue wig, thread, and glow-in-the-dark paint on Tyvek

One person can make a difference. A life partner like Julie had in Clay is a great example of that.

Bill Dorsch is another example.

Dorsch spent twenty-four years on the Chicago Police force starting in 1970, rising from patrol to detective. But toward the end of his career, he began

to perceive a pattern in the cases and behavior of a fellow detective named Reynaldo Guevara—the same man who had wrongfully sent Jacques Rivera to prison in 1990—and it made him sick.

"When I left in '94, I wanted to leave. I couldn't work there anymore. I didn't want to be a part of it," Dorsch said in a videotaped interview with the Marshall Project, a nonprofit, non-partisan news organization. "It's difficult to put a person in jail for something he did—they suffer for something they did," Dorsch said. "But to put somebody in jail and they're innocent. I don't want to live with that."

What Dorsch had seen was a fellow detective who, in Dorsch's view, didn't care whether a suspect was actually guilty, so long as the case was solved and closed. Dorsch's conclusion has been echoed in court rulings and civil judgments ever since that interview. In 2016, an Illinois State Appellate Court outlined an instance where Dorsch's courage in stepping forward saved one unnamed person from a wrongful prosecution.

"In the late 1980s or early 1990s he worked on a homicide case with Guevara," the court said. "They arranged a photographic array of possible suspects for two juvenile witnesses. When one of the witnesses hesitated selecting a photo, Dorsch witnessed Guevara point to one of the photographs and told the witness, 'That's him.'"

The next day, Dorsch talked to the witness himself, out of Guevara's presence, about the seriousness of the charges and the importance of proper identification.

"The juvenile admitted he had not actually witnessed the shooting. Dorsch immediately contacted the assistant state's attorney and all charges against the suspect were dropped the next day," the court said.

As of the summer of 2021, twenty people have been exonerated who were convicted with evidence gathered by Guevara, and dozens more cases were in progress, with victims still in prison. Tens of millions of dollars in court settlements have been paid by Illinois government authorities.

Some suspects that fell under Guevara's shadow—mostly young Latino men like Almodovar and Rivera (chapter 15)—told authorities they were beaten into confessing. Others have accused Guevara of assembling false witness accounts or burying evidence that would have helped the defense.

Almodovar was one of the twenty in that first wave of exonerees from Guevara's tainted case record. Arrested in 1994, the year that Dorsch quit the

department, he was convicted with another man of a gang-related double homicide the next year. He was nineteen at the time of the crime and very ambitious, working at a chocolate factory during the day and taking college classes by night. He testified at his trial that he'd finished an eleven-hour shift on the day of the killings, then taken a bus to class. Family members corroborated Almodovar's account, but the jury instead believed the prosecution witnesses who denied any suggestion that Guevara had influenced them. Both defendants got life without parole. Almodovar wasn't exonerated until 2017, when prosecutors in Chicago, after initially defending Guevara's handling of the case, finally agreed that proceeding with anything further was no longer in the "best interests of justice."

Guevara, meanwhile, had retreated into silence, refusing in almost every court inquiry to admit anything or even say anything. All he would reply was that, under the advice of his counsel, he was invoking his Fifth Amendment right not to incriminate himself. On one day in 2018, in a civil case looking into Guevara's trail of disaster, he took the Fifth more than two hundred times, according to the *Chicago Tribune*. Even in response to the most mundane questions—whether that was him in a photograph being shown to the jurors— the once formidable, crime-stopping Guevara cowered and hid.

Several Chicago police officers in addition to Dorsch eventually did the right thing, talking to defense attorneys when the storm against Guevara began to break. But by then the trail of devastation was already long and steep. Dorsch was proven right, but however courageous he was, it took two decades for Guevara's wrongdoing to be exposed.

"After I left," Dorsch said, "what I found out later from his being there, these cases multiplied. They multiplied." —KJ

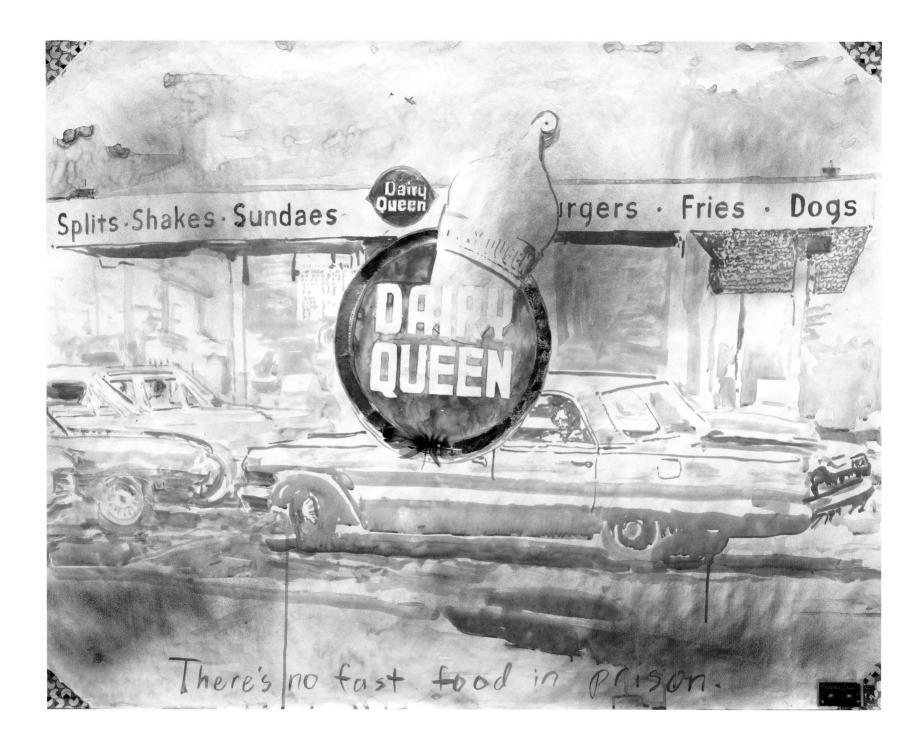

Burger, Fries, and Ice Cream at Dairy Queen

Ted Bradford is a Native American from Washington State. In the late 1990s, as he began serving time for a wrongful conviction, I visited Grayhorse Cemetery in Oklahoma, where Clay and I saw many tombstones with young women's porcelain photographic portraits from the Osage Nation. In the mid-1920s, thanks to good attorneys and oil revenue, the Osage were among the wealthiest people on earth. And among the most murdered—married by white husbands, killed for the inheritance. At the cemetery, the porcelain portraits are now defaced, used as target practice, riddled with bullet holes. For *Burger, Fries, and Ice Cream at Dairy Queen,* I left the holes unsewn. "Sundae" with the "s" punched with holes becomes "undae."

Bradford had his first meal at Dairy Queen. Why? Bradford's answer was pithy and trenchant: there's no fast food in prison. In the painting, a facsimile of his words floats in the parking lot.

Bradford was wrongfully convicted in Washington State, so I added an iron pigment to the image as indicator of place and tribute to Heidi Gustafson, a fellow artist who also lives in Washington and specializes in foraged ochre pigments. —JG

Most exonerations since 1989, when the first successful post-conviction DNA case unfolded—clearing a man named Gary Dotson of a rape he never committed—haven't come about through genetic evidence. That may come as a surprise to people who've read story after heartbreaking story in the news and come to think that science has come up with a foolproof way of preventing error, or uncovering it in the past.

2021
38 x 49.5 in.
acrylic, Heidi Gustafson pigment, fabric, thread, found feather, 24K gold, metallic gold candy wrapper, an offensively named Redskin Maid-brand button card, and glow-in-the-dark paint on Tyvek

DNA analysis has unquestionably led to powerful, positive changes—correctly identifying killers and rapists before their trials, clearing many people before trial, and allowing identification of sometimes long-dead victims or cold-case perpetrators. The Golden State Killer, for example, a notorious monster who terrorized California in the 1970s and 1980s, was ultimately captured in 2018 and identified as a former cop named Joseph James DeAngelo. He was brought to justice by genetic genealogy, which combines DNA and family-tree information, and has been used in many cases since then to identify both suspects and victims.

But in any given year, according to data assembled by the National Registry of Exonerations, the percentage of wrongful convictions cleared by DNA ranges from only about a half to a fifth. In many crimes, especially murder by gunshot, where no weapon is recovered and the killer never touched his victim, a

murderer's DNA isn't present. Drug crimes, robberies, and even some assaults often leave no genetic samples to test. Storage or handling of evidence that may contain DNA material is uneven and subject to challenge in court, which can lead to uncertainty in the minds of jurors or judges. Genetic evidence was a major contributing factor in only seven of the twenty-five first meal stories in this volume, including Bradford's.

What's more, legal experts like Cynthia Garza say the era of low-hanging fruit in DNA cases—recent enough to have testable evidence—is probably nearing its end. She heads one of the nation's pioneering experiments in addressing wrongful conviction—the Conviction Integrity Unit at the Dallas district attorney's office, which is tasked with looking for patterns of error and injustice from inside law enforcement. The integrity unit began its work in 2007 looking at old evidence that could be reexamined, with DNA as a starting place. "Once our unit

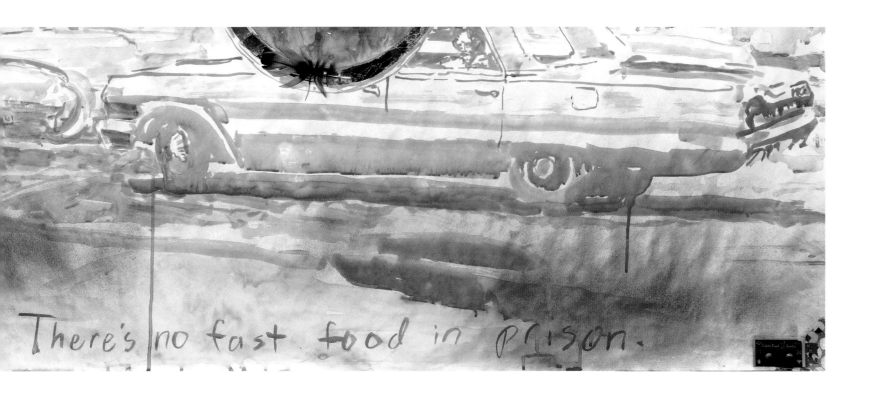

There's no fast food in prison.

started getting recognition for it, we started getting a lot of people just writing in, and then we started looking at the non-DNA cases," Garza told me in mid-2021. "We still have DNA cases to date, but the majority of our caseload is now non-DNA."

And even for people like Ted Bradford and others whose cases were ultimately cleared with the help of DNA, genetic evidence is not a magic bullet. Because wrongful convictions are driven by so many forces—and decisions along the way by judges, juries, prosecutors, police, and defense attorneys—exoneration is also rarely a quick process even with strong DNA evidence in hand.

Bradford spent nine years in prison after being convicted for the sexual assault of a woman in her home in Yakima, Washington, in 1995. But it wasn't until 2007 that the Washington State Court of Appeals reversed the conviction, citing DNA evidence obtained by Bradford's defense team at The Innocence Project Northwest Clinic at the University of Washington. Even then, however, prosecutors in Yakima were still convinced of Bradford's guilt and brought the case to a second jury, which acquitted him and cleared his name in 2010.

What the new world of DNA testing has revealed in cases like Bradford's is how faulty our initial judgments can be, and how, even in the face of what might appear to be scientific proof of error, an arrogant persistence of belief can soldier on. Conclusive evidence that the legal system has major holes and flaws that result in error is perhaps DNA's greatest contribution, many legal experts say, pushing us to look harder and deeper.

"What's changed is that the number of exonerations that are *not* DNA has risen considerably, and that's a factor of DNA in and of itself," said Maurice Possley, a Pulitzer Prize–winning journalist who spent twenty-five years at the *Chicago Tribune* and now works as a senior researcher for the National Registry of Exonerations. "People started to recognize, not only in the defense community, but ultimately over time, in the prosecution, that there are other contributing factors that can be the cause of wrongful convictions." —KJ

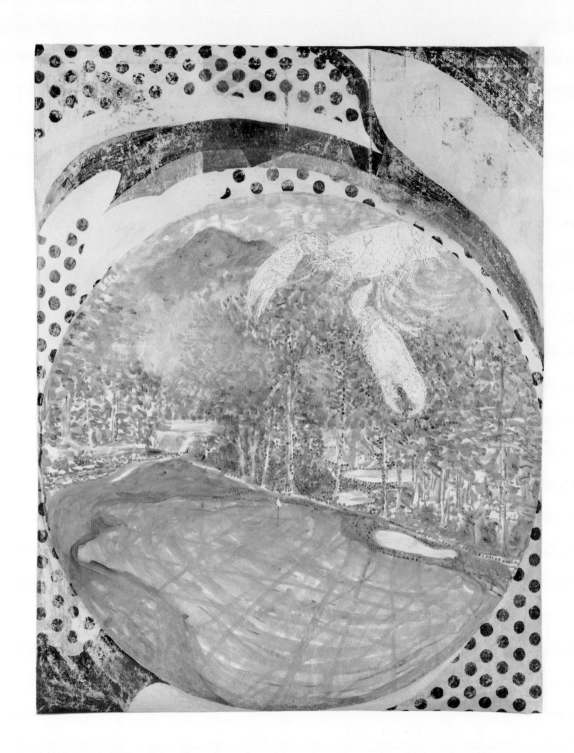

Golf to Red Lobster

2018
42.5 x 33.5 in.
acrylic on Tyvek
Cleveland Clinic Art
Collection (London)

In late 2018, I was a Fellow at the Center for the Humanities at Oregon State University and just getting started on *First Meal* when my colleague Joy Jensen walked up to me at the copy machine. She handed me a copy of the magazine *Golf Digest*. I am not, and never have been, a golfer.

Jensen had seen an article about Valentino Dixon and his art—drawings of golf courses created in prison by a wrongfully convicted man who somehow found his way to a powerful artistic expression. Dixon had also never golfed. His drawings, with their deep, almost surrealistic greens and fairways, got me thinking about Giotto's magical fourteenth-century paintings, which became an inspiration for this painting. Dixon's choice for his first meal was a lobster at the Red Lobster restaurant chain, so, in the painting, a lobster slices through the sky like a Giotto angel. After trying a number of Victorian transferware plate backgrounds, I changed centuries and referenced our own era's Roy Lichtenstein paper plate. The colors and compositions look contemporary. I painted and sanded numerous times. It is smooth as glass. —JG

Art can be transcendent, opening a window to reveal what we thought we knew but didn't really. It can be enigmatic, yielding a different interpretation to all who experience it. It can be healing, or maddening, or some combination of both.

Art created in confinement is a separate case. I can't listen to Olivier Messiaen's chamber music composition, *Quartet for the End of Time,* without thinking of its first performance in 1941, inside the German prisoner of war camp in Poland where it was written. The piano chords clunk-clunk-clunk along, sounding like something from a chain gang, while the cello mourns, slightly discordant off to the side like a weeping observer to the scene. I feel like I'm not

just hearing the sounds of longing, loss, and brutality in wartime from a distance, but that it's really right there all around me, closing in. That such beauty can be created within horror is miraculous.

Dixon's horror story began in August 1991, when he was arrested at age twenty-one, based on an anonymous tip, for the murder of a seventeen-year-old boy named Torriano Jackson in a street fight outside Louie's Texas Red Hots restaurant in Buffalo, New York. Two days after Dixon's arrest, another man—revealed years later to be the real killer—told reporters he'd shot Jackson, but detectives focused on Dixon instead. Prosecutors built a case based on several shaky eyewitnesses, some of whom later recanted and claimed to have been pressured by the police to shift their testimony. Dixon was convicted and sentenced to thirty-eight years to life.

What saved him was art. Through twenty-seven years in prison for a crime he didn't commit, his self-identity and self-discipline as an artist kept him going and eventually led to the truth of what had happened that night in the street outside the restaurant. And golf was the key, starting with the twelfth hole at Augusta National Golf Club in Augusta, Georgia.

Dixon had always loved art, but after his conviction he began drawing for escape—six to ten hours a day in Attica State Prison in upstate New York, where, as an inmate with model behavior, he was eventually allowed to pursue his work relatively unmolested. They were sketches of this and that, but they impressed those around him—including the warden, who at one point asked Dixon to draw something for him as a personal favor. He gave Dixon a photograph of what to the warden was a particularly beloved, or perhaps vexatious place: the par-three twelfth at Augusta.

Dixon finished the piece and kept going. Though he'd never played the game and knew next to nothing about it, he found that the photographs of golf courses he could get his hands on in prison somehow called to him. Golf has a power like that for people who fall under its spell. It's a game that demands both precision and wildness, played at the ridiculous boundary of the possible: there's a ball and a little hole, a million ways to connect the two that can go wrong, and no way to ever do it perfectly.

"I never copy holes exactly. I use a photograph as a starting point and then morph the image in my own way," Dixon said in a story that *Golf Digest* wrote about him in 2012, which introduced his story to the world. "Sometimes I'll find a tiny piece of reference material, like a tree on a stamp or mountains on a calendar, and then imagine my own golf course with it. I find the challenge

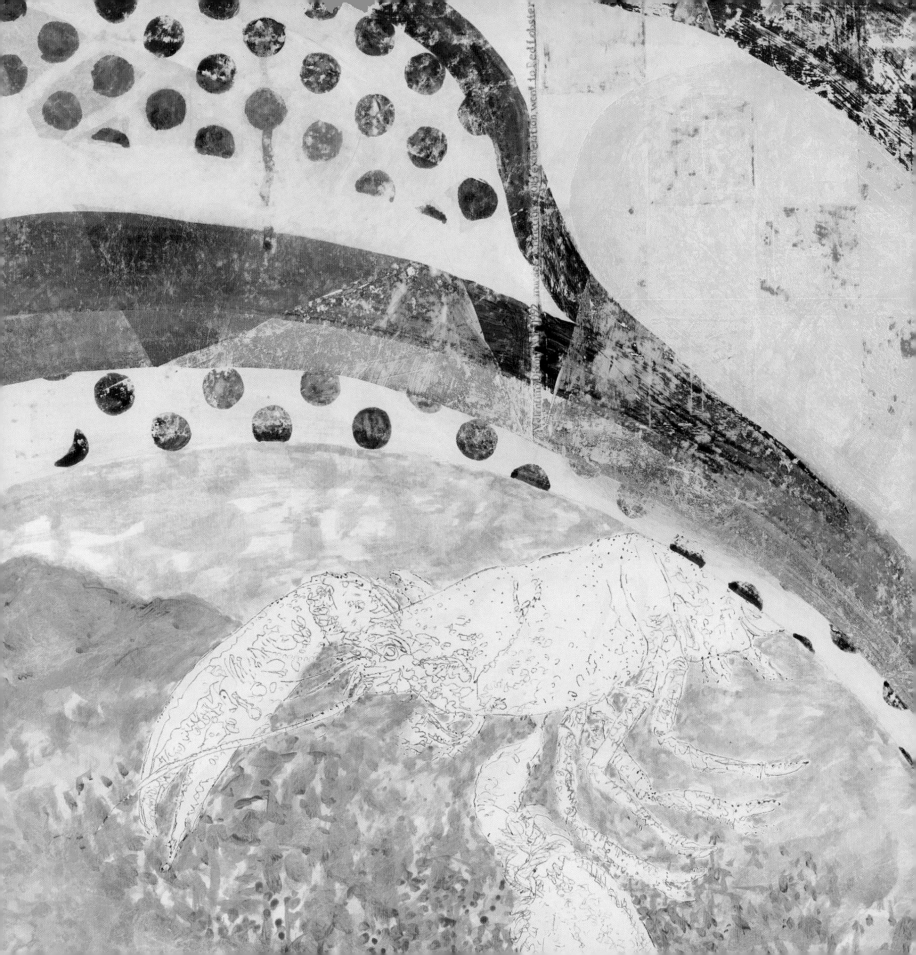

of integrating these visions very rewarding." And he felt the appeal of how golf courses flowed and were designed. "The look of a golf hole spoke to me. It seemed peaceful. I imagine playing it would be a lot like fishing," Dixon said.

Golf Digest ultimately conducted a deeper investigation into Dixon's conviction, which prompted a television investigation by *The Golf Channel*, and then a deep dive by three undergraduates at Georgetown University, who reinterviewed witnesses and produced a documentary revealing deep flaws in the original case. In 2018, the confession by the real killer that night in Buffalo was finally accepted and the charges against Dixon were dismissed.

Green's art reveals her own wildness and precision: that a Red Lobster can and should soar through air on the night of Dixon's first meal feels true. It's a slightly surreal leap, characteristic of Green's work, and Valentino Dixon's as well. His fairways and putting greens are sometimes too green to be real— wildly, impossibly green like a golf course from a dream. Green saw visual connections between things that never existed in the world outside her imagination, then made them real by expressing them in paint, or cloth or—in one of my favorite pieces in this collection—in the wild blue hair of a wig.

Many exonerees, in my interviews with them, or in comments they made to reporters or attorneys after release, use words like "surreal" or "unbelievable" to describe their emergence from prison, saying that it can feel like a transition between worlds or universes. To sit down to eat after that, to pause at the first bite, is a human experience beyond even the descriptive powers of art, and certainly beyond any words I could ever write.

That art can make the attempt at all is the heart of its power. An attempt requires an assertion of wildness, which, as Green often said, is an assertion of freedom itself. —KJ

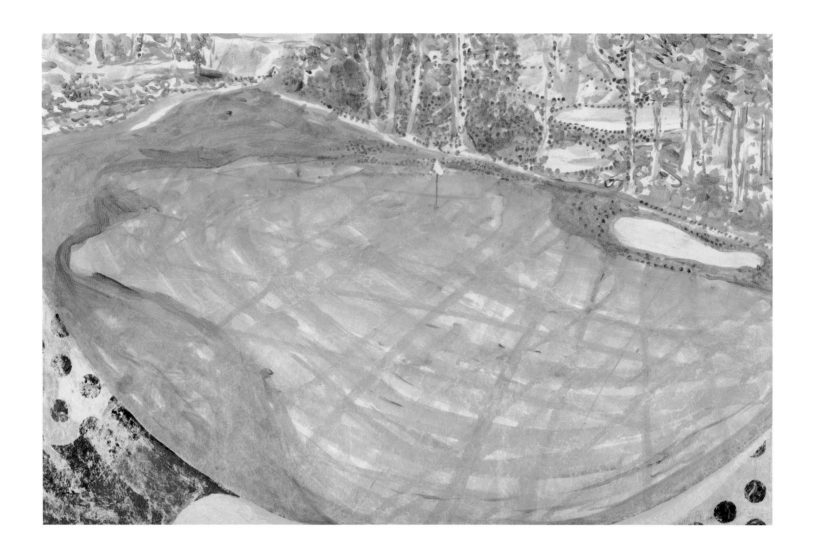

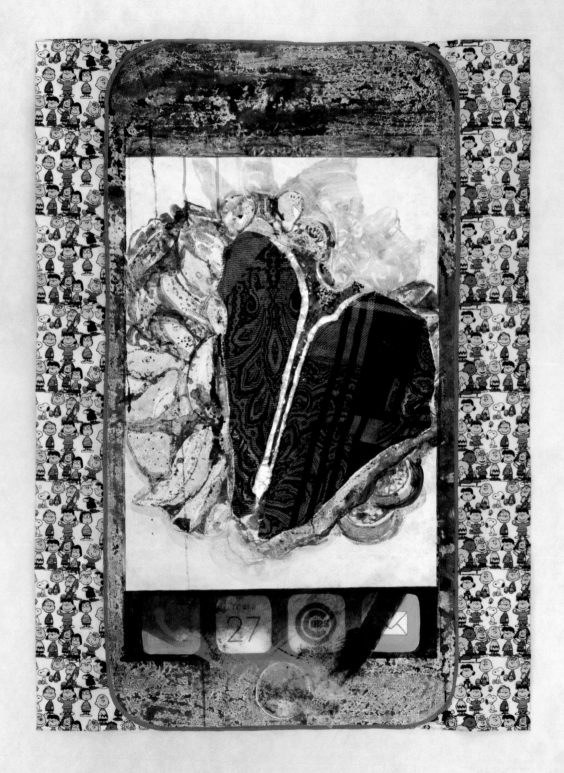

T-Bone Phone

Imagine missing twenty-seven years, during which time the cell phone was invented and widely adopted. This Illinois exoneree, Michael Evans, mentions being surprised by seeing them *everywhere* on his release, so I painted a huge iPhone with a steak on the home screen, made of silk and palladium. I painted icons for phone, email, and the Chicago Cubs. Instead of iCal, it's "Year 27." Nostalgic Charles Schulz *Peanuts* fabric—Charlie Brown's family and friends— surround the phone. Evans's first meal was shared with loved ones at his sister's home. They enjoyed T-bone steak and potatoes on what Michael Evans calls a glorious day. —JG

2020
48.75 x 36 in.
acrylic, palladium
leaf, fabric and
glow-in-the-dark
paint on Tyvek

Many of the crime stories I covered in New York and around the country for the *New York Times* were awful. Most, in the end, came down to some combination of stupidity, poverty, drugs, and youth; some cases had more of one element, some less. One case haunted me ever after, not because of its particular horror—though it had that—but because so much disaster and waste unfolded from a single moment. A fifteen-year-old named Shavod Jones took out a gun as a plainclothes cop named Steven McDonald approached him and two other boys in Central Park, and pulled the trigger three times. One bullet struck McDonald in the spine, leaving him paralyzed from the neck down and unable to breathe on his own. Jones was sentenced to ten years as a juvenile; he was paroled after eight-and-a-half and died in a motorcycle accident a few days after his release. So many lives were destroyed and thrown into a maelstrom of waste and disaster in the tiny muscle twitch of a finger. I played out that chain of loss in my head over and over, then and in the years since, thinking what might have been, and what unfolded after.

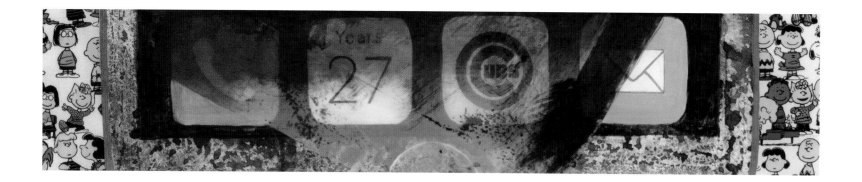

But learning about exoneree Michael Evans's story, I also saw how people can rise up from the horror they've been thrown into. His life was upended amidst the disaster of wrongful conviction. But the road he's gone down has been dictated just as much by what he did after that conviction.

He grew up in a religious household and had considered, in his youth, joining the ministry, or maybe becoming a writer, or both. Life seemed full of possibilities. "I never knew what I would have become," he said.

Society betrayed him at age seventeen in 1976 when he and a codefendant were convicted of raping and murdering a nine-year-old girl named Lisa Cabassa on Chicago's South Side. Twenty-seven years after the conviction, a retesting of the DNA evidence excluded Evans as the source of the semen that had been found in the girl's body. Prosecutors dismissed the charges, and, two years later, then-governor Rod Blagojevich signed a pardon.

Those years in prison, Evans said, brought him back to the church, deepening his faith by directing him back to what he'd felt as a child—that religion held the key to everything as a source of hope. In prison, he told me, staying hopeful was the only way to make it through.

I would always read, on a daily basis, in the Bible, the Holy Bible. I would read a scripture and I would meditate on it day and night. And it would encourage me to move on to another day, relax me and encourage me that a brighter day was going to come through my faith and belief in Jesus Christ as my Lord savior. I held onto that. That was only thing that kept me alive and believing. I didn't know. I could see no light in the end of the tunnel. But I believed that somehow, someway, God would make a way.

A central truth about the universe, Evans said, had become clear to him by then too—that the power of human beings is strictly limited, for better and for worse. The good things we can achieve in life—and the evil we can commit as well, not least locking up a person for a crime he didn't commit—are dwarfed by the mysteries and powers of things that are beyond us. Powerful, overwhelming forces crushed his early choices in life, Evans said, but they were in the end simply things of humanity, and thus limited in their ability to harm or destroy.

"There's more out there than just us," he said. "Man was not able to create the skies, the sun, the moon, to make the night and day and put it in harmony with the rain and snow and the changes of the season."

There's a sense of clarity and power that Evans gained during his wrongful sentence and he carries it with him now. He became, in a real way, the minister and the writer he imagined becoming: You can hear it in the strong, confident cadences of his voice. It took faith and effort, but he made it a mission to ensure that the moment that overturned his life was not the totality of his life. He made a life when a life was taken from him. —KJ

Blind Faith for Juan Rivera

Each painting in this series is embedded with symbols. In this case, a cut-up Illinois state flag forms a butterfly, the state insect. The flag's brown eagle wings become praying hands. A shirt cuff is painted in homage to the Illinois state tartan, with its rectilinear red, white, and blue. I took time to hand embroider Juan Rivera's reply on the Center on Wrongful Convictions's questionnaire form, but then, what is my time compared to twenty years spent in prison on a false charge? Rivera wrote of his meal: "It was full of spices and flavor and the food was beautiful. I wanted flavors, in there you don't get any flavors."

Rivera ate at a vegan restaurant named Blind Faith, a place he continues to visit. In a small act of homage—to faith, or vegans, or simply Rivera's spirit—there's a spice pouch in the upper left corner of the painting, which I imagine being replenished with fresh garam marsala, its thick sweet aroma spreading into every open space. —JG

2019
44 x 41 in.
Acrylic, silk and glow-in-the-dark thread, portion of Illinois state flag, vintage sampler, turmeric-dyed silk, Copic marker, garam marsala, and Tyvek

All faith is blind. I was taught that growing up in the Church of Jesus Christ of Latter-day Saints, where a memorable Mormon teacher hammered it into me: if you can know it or see it, it's not really faith at all. "Faith lives in a place," he said, "that you can't measure, test, or prove, a place beyond the reach of logic or argument. The things you find in that place may seem impossible, even perhaps absurd, but believing in them anyway is the only pathway we've got to really finding truth and God. You hold in faith what you cannot ever really know."

Blind faith can be a sweet thing—a dream of justice, success, redemption. But it can lead us to evil as well. To read the transcripts of Rivera's trials is to see blind faith exploited. The American legal system, and perhaps most especially

the role played by juries in deciding innocence or guilt, hinges on a belief that the system works, that real truth is being sought. In Rivera's case, prosecutors abused the faith of jurors to dismiss and even make fun of the idea that an innocent man could ever be framed and improperly brought to trial. But in Rivera's case that's exactly what was happening.

"Ladies and gentlemen of the jury," said an assistant state's prosecutor in the closing arguments to Rivera's trial in 1998, "we've been together for over a half a month, and the evidence in this case shows not beyond just a reasonable doubt, not beyond a shadow of a doubt, beyond *any* doubt, beyond *any* question, that the defendant, Juan Antonio Rivera, brutally butchered, murdered, and raped Holly Staker. There is no question about it. There's none."

What proved that guilt even more, the prosecutor continued, was the suggestion by the defense, and by Rivera's own protests during his interrogation, that inappropriate pressure had been applied to extract a confession. Only guilty people would ever say such a thing, the prosecutor suggested in final arguments to the panel of twelve jurors and two alternates.

"Even if you fourteen people were the worst police-hating conspiracy theory nuts in the world, you've got to ask yourself: how could this grand conspiracy get so many evil police officers to lie to try to frame an innocent man of this horrible crime?" the prosecutor said.

"You saw those men testify from the witness stand," he continued. "Did you see any hint, any scintilla, that those men were monsters that would just frame an innocent man and let the savage butcher go free among us? Did you see that in their personality? Did you see that in their eyes? That's ridiculous."

Then the prosecutor homed in on Rivera's police interrogation. "Why is he convinced at that time that the police are trying to pin this on him? It's not because of anything that they've done. It's because he knows he did it."

And yet, to read the trial transcripts now, after the complete rebuke of the prosecution's case by a state appeals court in 2011, is to see nothing but doubt and failure. Holly Staker was eleven when she was raped and stabbed to death in 1992 while babysitting at a home in Waukegan, Illinois, an hour north of Chicago.

The appellate court, ruling nearly twenty years after Holly's murder, said the errors committed against Rivera were so grave that his conviction was "unjustified and cannot stand." Evidence suggested, the court said, that interrogators had manipulated Rivera into confessing and fed him information about the case as they questioned him. Prosecutors had presented "highly improbable" arguments as to why a DNA test ruling out Rivera should be disregarded by the jurors. "We hold that no rational trier of fact could have found the essential elements of the crime beyond a reasonable doubt," the court said.

One of Rivera's defense lawyers, Patrick Tuite, told the 1998 jury—presciently and correctly—that injustice loomed before them, and they could avert it by acquitting Rivera and waiting for the real killer to be found. "We can't do anything about the first tragedy, to bring Holly back," he said. "The second tragedy is that he has been sitting here in custody, and the real killer is still out there," he added, referring to Rivera. "That's the tragedy that you can do something about. You have the power to do that."

In 2015, Lake County, Illinois, settled Rivera's civil lawsuit for $20 million, at the time the largest payment in state history resulting from law-enforcement error.

Cynicism, faith's opposite, can come easily in reading court transcripts and interviewing legal experts about a case like Rivera's. Faith in science, in the judicial

system, and in our own human abilities to judge fairly the evidence presented to us can feel weakened and eroded. But for all the darkness in these *First Meal* stories, there is also a basis for hope. Knowing how error can come about, and having tools by which to fight it—bearing witness to it, as Green would say— is part of how we reduce error in the future.

"We're moving the ball, slowly but surely," said Cynthia Garza, the conviction integrity unit director at the Dallas district attorney's office. The Dallas unit was established in 2007 and was one of the first; similar units have since spread across the nation, led in some places by defense attorneys who had been doing exoneration work right up until the day they took an office at the DA.

The integrity unit in Philadelphia is led by a woman who worked for the Dallas district attorney. In Queens County, New York, it's led by an attorney hired away from the New York Innocence Project. In Indianapolis, one of the first attorneys in the unit was a career public defender.

"Some areas have been a little slower than others to implement these processes and procedures, to implement the laws that it's going to take to help curb these wrongful convictions in the future," Garza said. "But there is improvement."

Maurice Possley at the National Registry of Exonerations said that seeing structures of law enforcement shift from within is an element of hope. "You've got to change the culture," he said. "And what I see, what I'm encouraged by, is what I see starting to change the culture. That's what some of these conviction integrity units are doing."

State legislatures, if only from the growing awareness that wrongful convictions can also be hugely expensive in civil damages, have also made important structural changes in some states. Two laws in Texas make it harder for police and prosecutors to withhold information that could be of potential use to a defendant. The Illinois legislature passed a law in 2021 banning police from using deception when interrogating a person under age eighteen. Such techniques— suggesting, for example, that a raft of evidence had already been produced when investigators had almost none, or making false promises of leniency—have played a role in almost a third of wrongful convictions that were later cleared by DNA evidence, according to The Innocence Project.

Believing in systems of law doesn't mean surrendering to blind faith that they always work, and trying to make those systems better and fairer doesn't require a cynical dismissal—believing that they're always doomed to failure by biases of race or class or something else. From the acknowledgment of human frailty can come strength, if it also comes with safeguards that prevent our worst failings.

One foot in front of the other, with diligence, gets you to a better place than you were, and that's something.

But as veterans of the system say, you also have to go in with eyes wide open. Garza at the Dallas DA's office regularly gets asked for advice by prosecutors around the country about how integrity units should work and what they should focus on. One of her first answers: investigators should throw out the idea that confessions or guilty pleas are always indicators of guilt.

"There are some units around the country that don't accept cases where the person has pled guilty," she said. What she tells them is that as much as they might not want to believe it, innocent people sometimes just surrender to pressure. They're no less in need of exoneration. "We've had plenty of exonerees that have pled guilty. It sounds counterintuitive, that with everything, someone that was innocent would plead guilty, but it happens, and we know that because it's happened in Dallas County and we're not an anomaly. It's going to happen in other places."

Finally, Garza said she tells new integrity unit attorneys to think differently. "Just kind of open your mind, open your mind to all these different possibilities," she said.

With humility, and with eyes wide open, the old arrogance of infallibility crumbles. —KJ

Burger, Vegas, and Fiancée

A news report about this exoneree's post-release plans captured my eye and imagination. A burger. Vegas. Reuniting with a fiancée. Reading this, a fully formed layout came to mind: vintage Vegas sign, large burger, huge engagement ring. Alluding to the magnitude of a wrongful conviction, these paintings are large, flag-like. Big burger, big painting. Palladium costs more than 24K gold, and here I combine the valuable with mundane: palladium with Tyvek. Precious metals, but what of precious life.

The space we inhabit is always at the border of the precious and the mundane. What seems like a mundane day suddenly turns upside down. All the things that went wrong, all the ways our legal system failed another southern Black man. And we see how precious that life is. —JG

2020
48.75 x 36 in.
acrylic, palladium
leaf, fabric and
glow-in-the-dark
paint on Tyvek

What do we really need? Food and water, shelter from the elements, and companionship to stave off the loneliness that haunts the world.

It's all frills after that.

A burger. In Las Vegas. With a fiancée. Is there more in the universe, really, that could be packed into such a simple and profound package? That this exoneree chose to remain anonymous in some ways makes those choices even more powerful. By withholding his name, he asserted a power of self-definition that he was denied in prison. *This much of my story I will tell, and no more.*

He chose to go to Vegas, a place of outlandish extremes and absurd excess, and yet chose simplicity when he got there: a hamburger, in a city that prides itself on serving you up anything you want in whatever ridiculously embellished way you choose.

As for the fiancée, it's impossible to glimpse into any couple's relationship or guess what came next. But I for one believe in true love—because I want to,

because every wrongfully convicted person deserves it, and because the world would be at least a little bit better if the exoneree and his fiancée had stars in their eyes walking down the strip. I imagine them hand in hand as a warm desert wind blows in, beckoning the lovers to a laser light show in a spewing water fountain, a fireworks display, and every other silly, oversized spectacle Vegas has to offer.

Then let the lights flash. Let the water fountain dance and the fireworks burst. Gasp in delight and believe that something decent in the world may yet come. Choose to blend back into the crowd if you want, or keep on walking right out of town into the desert darkness. —KJ

Blueberries Hand-fed to Julie Rea

Jason Strong led me to other exonerees and cases; Julie Rea did too, through art. I mentored Rea on art, and Rea has begun mentoring others, and so I'll let her words speak. She describes *First Meal* as "a form of Kintsugi work to exonerees' lives—applying a bit of precious gold to mend the fractured pieces so they can perhaps become whole again. It offers a hope to create a new whole. Something more beautiful, and again useful."

Art must speak for itself too, and things emerge for reasons I can paint but cannot put into words. In her *First Meal* questionnaire, Rea talked about being fed blueberries, a favorite fruit, by hand, by a friend. Moved and inspired, I flew to Denver to meet her and to deliver Oregon blueberries. And so we became friends.

In the painting, a historical plate serves as the foundation, and for reasons I can paint but not explain—but I think Rea will somehow understand—I painted, behind Rea and a friend in contemporary clothing, a white man in fine Victorian clothes, holding court. —JG

2018
35 x 47 in.
acrylic on Tyvek
NoMad Hotel
Collection (London)

Food and punishment have an old, intertwined relationship. Bread and water. Execution by starvation. Penal colonies and the Siberian Gulag, where, as Solzhenitsyn described it, little could be grown to make up the shortage in what authorities provided. And, of course, in modern America, money. The less you spend on anything in a for-profit prison system—which houses about one in twelve inmates in America—the more profit you can make. Standing up for the quality of what is served in a prison is nobody's political constituency.

In prison, Rea told me, food is all about control.

On food days when we would have a piece of fresh fruit on our tray, they would make us go through really quickly. And so girls would grab that fresh fruit and stick it in their clothes to try to steal it on the way out so that they could take it back and eat it on the unit. And so right outside, they would shake us down. And so you would see all

these oranges or all these apples that were thrown on the side of the ground, outside the common dining room, the CDR. And so they would just go to waste. And on days when we had really bad meals, you know, stuff that nobody wanted to eat, they would make us sit there and sit there and sit there. That's the kind of insanity surrounding food that you see in a prison. I've only been in one, so I can't speak to others, but I think it's pretty safe to say that that was not a unique experience. If you can control an environment, then you can control an individual.

Rea had health problems as a child—an autoimmune disorder that improved after she started eating a diet with lots of vegetables and few processed foods. Married at seventeen, she carried the value of eating well into motherhood after her son Joel was born in 1987.

"I changed to an organic and whole-food diet. I bought chickens off the farm and did my cooking from scratch and bought produce through a co-op. I did all real foods—live foods—and paid close attention to supplements. I used apple cider vinegar and garlic a lot and built up my immune system so that it was very healthy and balanced. And I was able to put my autoimmune disorder into remission, and it was in remission for years," she said.

Until everything fell apart.

On October 13, 1997, Joel was murdered, stabbed to death in his bed. Rea told the police that a man had gotten into her home, stabbed Joel, and then escaped after a struggle in which Rea was injured. The police were skeptical. Few children are ever killed this way, by a stranger breaking into a house and heading to a child's bedroom bent on murder, especially in a rural town of four thousand people like Lawrenceville, Illinois. Three years after the murder, Rea was indicted. Convicted in 2002, she was sentenced to sixty-five years. Her world, her family, and her health all seemed to blink into darkness.

Her case was retried in 2006, after the real killer's confession came to light. Random, spontaneously chosen murders do in fact occur, and Joel's killer was a perpetrator of exactly that sort of crime. He'd broken into a home in Lawrenceville, he admitted, killed a young boy he didn't know, then fought with a woman who'd rushed to defend her child. A clearer examination of Rea's injuries also concluded that they couldn't possibly have been self-inflicted, as the prosecution had argued in her first trial.

After her exoneration, Rea's friends remembered her old food values and dietary goals. And they all knew as well the toll that prison had exacted on her health.

Fruit. Fresh things. Those had to be on the menu for her first meal.

It was also a day for things that felt new. When Rea walked out of the prison, she slipped her shoes off, wanting and needing to feel the grass under her feet. "I hadn't been able to do that for years," she said. "There was just this joy with life, that you want to savor the moments. And you want to experience the things that you haven't experienced. It's kind of like death-to-life again—I would assume that's something like coming out of a coma," she said. "It's just a celebration of life again."

The blueberry moment came out of nowhere. As her friends all gathered around her, a woman named Denise just walked up, reached out, and began feeding berries into Rea's mouth. "I think it was a spontaneous act," Rea told me. "I was standing up and saying hello to people, and she just came up to me. That's kind of a Denise thing. I mean, Denise is thoughtful and creative and inventive, and I think she just wanted to be the one to give me the first bite of something good."

Something good. There are so many layers embedded in that phrase, from the biochemistry of berries and their antioxidant properties to the simple, warm, impulsive gesture of a friend. But one certainty unites everything: it was time, at last, for Rea to begin healing. —KJ

Afterword

The Center on Wrongful Convictions's partnership with artist Julie Green has been an inspiring journey in discovering new perspectives from which to tell the heart-wrenching and redemptive stories of the innocent men and women who have been wrongfully convicted and incarcerated in the United States.

To be incarcerated is to be deprived. The carceral system doesn't concern itself with innocence or guilt; it is a system of punishment, mistakes be damned. Errors that lead to wrongful conviction are not seen as the prison's problem. Once you pass through the prison gates, you have no status and no name. Everyone is deprived. Deprived of color, taste, movement, choices, decision-making, human contact, fresh air, clean clothes, and nourishing food. Deprivation is about hopelessness, and with deprivation at the heart of the prison system, hopelessness is the goal. It takes extraordinary fortitude to survive incarceration with even a shred of hope. Now imagine being innocent and incarcerated.

Every day that an innocent person stays in prison is a mistake, a continuous error. An error compounded by every mistaken decision made by prison wardens and prison leadership. You should not be in prison. You should not be a man forced to eat a soy-based diet. You should not be a woman who can't get the necessary proteins and calcium for healthy teeth and bones. You should not give birth chained to a bed. You should not be a person with no choices. Yet in most states in the United States, when the innocent are identified and acknowledged as wrongfully convicted and incarcerated, we do as little as possible to right the wrong, to rehabilitate those who have intentionally been driven to mental and physical hopelessness. Typically, in fact, we simply open the prison door so the innocent can leave; then we shut the door firmly behind them after they have gone. No support. No services. No direction. No acknowledgment of the damage done by years without choices, without fresh fruit or fresh vegetables or color of any kind.

Anonymous, 2019
Untitled
7.5 x 10 in.
watercolor on paper
This painting is by a female exoneree who chose
to have her name withheld due to the particularly
vulnerable nature of the work.

It is time for the world to see the explosion of humanity that is expressed when someone society has deprived is finally free for the first time—to choose their own path, choose what they put in their bodies, choose their food. The awe a person can feel just holding an orange. Tears at seeing fresh, vivid food. Savoring blueberries. Having choices, any at all.

The Center on Wrongful Convictions is deeply proud and humbled by the collaboration with the extraordinary artist Julie Green and award-winning journalist, Kirk Johnson, to bring these beautiful powerful paintings and vital stories to the world.

—*Sara Sommervold, Center on Wrongful Convictions*

Acknowledgments

Beginning *First Meal* in late 2018, I reflected on how little I had in common with exonerees. Besides a call for social justice, who was I to make these paintings?

I hadn't been wrongfully convicted. I hadn't been in prison, hadn't feared for my life.

But in November 2019, a routine gyn exam turned up metastatic ovarian cancer. With no known family history, I learned that I carry the deadly BRCA genetic mutation, with a 70 percent chance of getting breast cancer and a 30 percent chance of getting ovarian cancer. There's a simple blood test available through one's doctor that can identify the BRCA genetic mutation. One in four hundred have it. This knowledge can be lifesaving. I wish I had known.

A few months after my diagnosis, the pandemic took hold and because of my high health risks we went into self-imposed lockdown. I didn't go to a post office for a year, or a grocery store for over a year. We are privileged to have the help of friends and Instacart.

Throughout illness I am given updates on my percentage of living x amount of time: you have a 60 percent chance of living five years if you undergo chemo. Again this feels like a sentence, pronounced by a judge. I've talked with others with serious illnesses and they too felt they had been sentenced.

In fall 2020, Oregon experienced an unprecedented wildfire season. For a few days we had the worst air quality in the world. The sky was yellow for almost a month. We hadn't yet equipped our 1930s house for such a crisis; the air in the house was bad, but much worse outside. I developed a large rash and shortness of breath.

And it was in the midst of all that—cancer, COVID, and forest fires, while painting *First Meal*—that I first really felt I could begin to relate to some of the experiences of the individuals whom I was painting and whose stories I'd absorbed. I was stuck in the house, in a sealed-off room, not seeing anybody except Clay and our cat Mini.

First Meal is collaborative. To each wrongfully convicted individual: I am sorry our legal system failed you. I am grateful for your release. I am grateful for your time and trust in sharing your food story. On completion, a digital print of the painting and an honorarium is sent to each participant. Financial proceeds from *First Meal* are to be shared with the Center on Wrongful Convictions at Northwestern University, to support their ongoing efforts for wrongfully convicted persons. Lawyers who fight for legal exoneration and inmate release, through long hours and huge caseloads, are doing important work; I wish every US attorney would donate one day a week to these efforts.

The idea of *First Meal* as a book was its own journey. After reading Kirk Johnson's *New York Times* feature on *The Last Supper*, Angela Lustig and Dale Taylor set things in motion by bringing my series *The Last Supper* to Illinois for exhibition. The Block Museum's Lisa Graziose Corrin introduced me to the wonderful staff at Northwestern Pritzker School of Law and the Center on Wrongful Convictions. I initially worked with Karen Daniel. Together, we wrote the interview form, then Daniel and CWC interns contacted exonerees, before sending me the completed forms. Then, in 2019, Karen Daniel died tragically, out walking, hit by a truck. Sara Sommervold, who was CWC's Deputy Director at the time, continued the collaboration in Daniel's memory and spirit. Thank you.

When this book project came up, my first thought was to ask Kirk. I am grateful schedules aligned and we could work together. The former *NYT* courtroom reporter and bureau chief describes legal catastrophes later deemed wrongful convictions. His contribution turned out as I imagined: factual, eloquent, personal, and illuminating. Collaborating has been an honor and a great pleasure. Thank you.

Oregon State is a true research university. I am inspired by faculty and students alike. Ed Ray, Ed Feser, Chris McKnight Nichols, the Center of the Humanities, Alex Walchli, Larry and Sue Rodgers, Coleen Keedah, Jim Folts, Art and Art History faculty, thank you. Theo Downes-Le Guin, your support over the years humbles me and has made all the difference. Upfor Gallery, Heather Birdsong, Melissa Soltesz, The Armory Show, Grace Towery, Meagan Atiyeh, Kandis Brewer Nunn, the Ford Family Foundation, Roger Shimomura, Jaune Quick-to-See Smith, Midori Yoshimoto, New Jersey City University, Elizabeth Houston Gallery, Sarah Sentilles, thank you. Lee Ann Garrison and Jim Gangwer each gave me glorious, vintage airbrush equipment, thank you. The first fourteen *First Meal* paintings were photographed by Mario Gallucci, paintings fifteen onward by Clay Lohmann. Anna Fidler walks five doors down to give excellent studio advice, thank you. Mom believes in us, thank you. Most of all Clay Lohmann, thirty-four years' collaboration on art and life, thank you. —JG

Many of the conversations I had in the course of writing this book were power-ful, haunting, harrowing and yet often, at the same time, beautiful. I was left in awe every time I interviewed an exoneree, and as much as I tried to thank them for their time in talking to me, over the phone or on Zoom, I want to do so here again. I was honored by hearing the stories of the strength they found to endure and the ways they were able to keep hope alive. I sometimes hung up the phone near tears, and always wanted that night to tell Fran—my wife, confidante, and best friend for the last four decades—what I'd heard that day.

Thank you too, to the many attorneys, law professors, and researchers who walked me through the causes and consequences of error in criminal justice, shared case documents, and pointed me in the direction of other experts. Any errors committed in these pages are from my failing, not yours. Thanks also to Kim Hogeland at Oregon State University Press and Midori Yoshimoto at New Jersey City University for their steadfast belief in the project, and to Jon Cox and Micki Reaman for their careful and sensitive editing of the manuscript. Erin Kirk's work on the design and the cover was stunning, and Marty Brown was masterful in guiding the book down the tricky path of marketing and produc-tion. Theo Downes-Le Guin was a constant in his cool counsel and bedrock support. Nothing of this book would have happened at all, of course, without Julie's brilliant art, and just as crucially, her dogged moral compass. *First Meal* is one of the many things that exist because Julie marched through the open-ended possibilities of life, making choices. I will miss her disarming and some-times devastating combination of sweetness and steely hatred of injustice. I will miss the warm humor, the generosity, and the creative hats. My debt to her for the invitation to participate in this work is immense and unending. —KJ

Notes and Sources

Introduction

Kirk Johnson telephone interview with Jennifer Blagg, June 17, 2021

Kirk Johnson telephone interview with Daniel Taylor, July 20, 2021

Chapter One: Champagne for Kristine Bunch

Center on Wrongful Convictions *First Meal* interview form

Kirk Johnson telephone interview with Kristine Bunch, June 18, 2021

Kirk Johnson telephone interview with B. Michael Mears, June 18 2021

National Registry of Exonerations case summary

Kirk Johnson, "Dish by Dish, Art of Last Meals," *The New York Times,* January 26, 2013,
 Section C, Page 1

State of Indiana, County of Decatur State of Indiana v. Kristine M. Bunch, Transcript of
 Proceedings of Appeal held September 6, 1996, Decatur Circuit Court

Chapter Two: Pepsi-Cola Monticello for Horace Roberts

Center on Wrongful Convictions First Meal interview form

Richard Winton, "An affair led to his conviction in a co-worker's murder. Now he is free
 and the victim's husband has been arrested," The Los Angeles Times, October 15, 2018

Richard Winton, "Man exonerated in 1998 Riverside killing sues county and Sheriff's
 department," The Los Angeles Times, October 1, 2019

California Innocence Project video, attorney Mike Semanchik Instagram post and emails
 with Julie Green

National Registry of Exonerations report, 25,000 Years Lost to Wrongful Convictions
 (June 14, 2021)

National Registry of Exonerations case summary

Chapter Three: At Home With Family

Center on Wrongful Convictions interview form

Justice Research and Statistics Association, Crime and Justice Atlas, historical data, 2000

Kirk Johnson, "Everybody is Edgy as Goetz Trial Opens," The New York Times, May 3, 1987, Section 4, Page 6

Kirk Johnson, "Goetz is Cleared in Subway Attack; Gun Count Upheld," *The New York Times*, June 17, 1987, Section A, Page 1

Alan Feuer, "Another Murder Conviction linked to Scarcella is Reversed," *The New York Times,* January 11, 2018, Section A, Page 18

Kirk Johnson telephone interview with Maurice Possley, June 24, 2021

Michael Powell and Sharon Otterman, "Jailed Unjustly in the Death of a Rabbi, Man Nears Freedom," *The New York Times,* March 20, 2013, Section A Page 1

Troy Closson, "After Case Dissolves, Man Who Languished in Prison Wins $10.5 million," *The New York Times,* May 6, 2022, Section A Page 17

National Registry of Exonerations case summary

Chapter Four: Savory Steak

Center on Wrongful Convictions First Meal interview form

Kirk Johnson telephone interview with Johnnie Savory, July 30, 2021

National Registry of Exonerations case summary

Chapter Five: Thank God I'm Home said Marcel Brown

Center on Wrongful Convictions *First Meal* interview form

Kirk Johnson telephone interview with Marcel Brown, June 30, 2021

National Registry of Exonerations case summary

Marcel Brown police interrogation transcript, September 3, 2008

Bill Dwyer, "Oak Park Man Arrested in Galewood Murder," *Austin Weekly News*, September 10, 2008

Chapter Six: Shrimp and Grits at Little Goat

Center on Wrongful Convictions *First Meal* interview form

James Green, *Death in the Haymarket: A Story of Chicago, the First Labor Movement and the Bombing That Divided Gilded Age America* (Pantheon Books, 2006)

Kirk Johnson telephone interview with James R. Kluppelberg Sr., July 21, 2021

National Registry of Exonerations case summary

Chapter Seven: J.B. Burgers

Center on Wrongful Convictions *First Meal* interview form

Kirk Johnson telephone interview with Jennifer Blagg, July 2, 2021

Kirk Johnson telephone interview with Jeffrey S. Gutman, and email exchanges, August 5, 2021

Erica Goode, "When DNA Evidence Suggests 'Innocent,' Some Prosecutors Cling to 'Maybe,'" *The New York Times,* November 16, 2011, Section A, page 19

Jonathan Barr v. Illinois State Police Officer Tasso, et al. United States District Court for the Northern District of Illinois, Eastern Division, Plaintiff's complaint, October 17, 2012

Ariel Spierer, "The Right to Remain a Child: The Impermissibility of the Reid Technique in Juvenile Interrogations," *New York University Law Review,* Vol. 92: 1719, November 2017

National Registry of Exonerations case summary

Chapter Eight: Liver

Center on Wrongful Convictions *First Meal* interview form

National Registry of Exonerations case summary

Jennifer Thompson-Cannino and Ronald Cotton, with Erin Torneo, *Picking Cotton: Our Memoir of Injustice and Redemption* (St. Martin's Press, 2009) pages 50, 70, 275-282

Chapter Nine: Holding Orange for Jason Strong

Center on Wrongful Convictions *First Meal* interview form

Kirk Johnson telephone interviews with Jason Strong, April 18, 2020 and June 23, 2021

Kirk Johnson telephone interview with Debbie Kenny, April 20, 2020

Kirk Johnson telephone interview with David Luger, February 18, 2020

National Registry of Exonerations case summary

Chapter Ten: Hyde Park Steak House

Center on Wrongful Convictions *First Meal* interview form

National Registry of Exonerations case summary

Trevor Jensen, "Thomas J. Maloney: 1925-2008," *Chicago Tribune*, October 22, 2008

Gregory Pratt, "Judge Orders City to pay $5.6 million in legal fees to wrongfully convicted ex-El Rukn gang member," *Chicago Tribune*, January 2, 2018

Nathson Fields v. City of Chicago, United States Court of Appeals, Seventh Circuit, opinion by Circuit Judge Ilana Diamond Rovner, Nov. 20, 2020

United States v. Thomas J. Maloney, United States Court of Appeals, Seventh Circuit, opinion issued November 29, 1995

Mickey Ciokajlo, "Man pardoned by Ryan borrows to post pal's bond," *The Chicago Tribune,* May 10, 2003, Section 1 page 14

Associated Press, "2 Gang Members Convicted," *The Times* (Munster Indiana), June 29, 1986, page B-12

Chapter Eleven: Golden Corral: Everyone Deserves a Good Meal

Center on Wrongful Convictions *First Meal* interview form

National Registry of Exonerations case summary

National Registry of Exonerations, "Snitch Watch," May 13, 2015

Katie Zavadski and Moiz Syed, "30 Years of Jailhouse Snitch Scandals," *ProPublica.org*, December 4, 2019

Pewtrusts.org, "Jailhouse Snitch Testimony: A policy Review," Oct. 1, 2007

Center on Wrongful Convictions, "The Snitch System: How Snitch Testimony Sent Randy Steidl and Other Innocent Americans to Death Row," Winter 2004-2005

Chapter Twelve: Mom's Rainbow Trout

Kirk Johnson telephone interviews with Leslie Vass, July 20, 2021 and July 21, 2021

National Registry of Exonerations case summary

Chapter Thirteen: Burger Downtown for Mark Clements

Center on Wrongful Convictions *First Meal* interview form

Kirk Johnson telephone interview with Andrea Lyon, June 20, 2021

Stanley Wrice v. Jon Burge, John Byrne and Peter Dignan, Memorandum opinion and Order, United States District Court for the Northern District of Illinois, Eastern Division, Judge Harry D. Leinenweber, January 27, 2020

Petition for appointment of special prosecutor in the Burge Case, Circuit Court of Cook County, Illinois, No. 2001 Misc. #4, April 6, 2001

Sam Roberts, "Jon Burge, 70, Ex-Commander in Chicago Police Torture Cases, Dies," *The New York Times*, September 20, 2018, Section B, Page 13

Keith Walker v. Administrator of the Estate of Former Chicago Police Commander Jon Burge, et. al, complaint, United States District Court for the Northern District of Illinois, Eastern Division, August 10, 2021

National Registry of Exonerations case summary

Chapter Fourteen: Beef House Near Danville

Center on Wrongful Convictions *First Meal* interview form

Kirk Johnson telephone interview with Bob Wright, June 30, 2021

Gordon Randy Steidl v City of Paris et al, U.S. District Court, Central District of Illinois, Urbana Division, May 27, 2005, Petitioner's complaint

National Registry of Exonerations case summary

Chapter Fifteen: Pizza Pennant

Center on Wrongful Convictions *First Meal* interview form

Kirk Johnson telephone interview with Jacques Rivera, June 20, 2021

Fernando Bermudez, 2021

Art4Justice

12 x 12 in.

acrylic, spray paint, and markers on canvas

Jason Meisner, "Jury finds Chicago cops framed man for 1988 murder, awards him more than $17 million," *The Chicago Tribune*, June 29, 2018

National Registry of Exonerations case summary

Chapter Sixteen: Whopper, Fries and Then

Center on Wrongful Convictions *First Meal* interview form

Witness to Innocence website, exoneree profiles

Maureen Cavanaugh, radio interview with Juan Roberto Melendez, *KPBS Public Media*, San Diego, California, March 17, 2011

National Registry of Exonerations case summary

Dave Eggers and Lola Vollen (editors), *Surviving Justice: America's Wrongfully Convicted and Exonerated,* (Verso Books, 2005). Oral history interview with Juan Roberto Melendez.

Chapter Seventeen: MacManhattanMom

Center on Wrongful Convictions *First Meal* interview form

Kirk Johnson telephone and video interviews with Fernando Bermudez, July 1, 2021 and July 21, 2021

National Registry of Exonerations case summary

Chapter Eighteen: Huwe Burton Said Truth Freed Me, Music Kept Me Sane While I Waited

Center on Wrongful Convictions *First Meal* interview form

Email exchanges between Huwe Burton and Julie Green

Kirk Johnson telephone interview with Huwe Burton, June 22, 2021

Huwe Burton v. City of New York, et al., complaint, United States District Court, Southern District of New York, October 28, 2020

Jan Ransom, "Three Detectives Obtained a False Murder Conviction. Was it One of Dozens?" *The New York Times*, February 15, 2021, Section A Page 1

National Registry of Exonerations case summary

Chapter Nineteen: Aunt's House

Center on Wrongful Convictions *First Meal* interview form

Jason Meisner, "Former Chicago detective takes the Fifth more than 200 times in wrongful conviction trial," *Chicago Tribune*, June 12, 2018

Maya Dukmasova, "'I'm the bad guy now:' A retired cop on outing police misconduct," *The Chicago Reader,* September 12, 2019, with link to Marshall Project, "We are

Witnesses: Chicago," video interview with Bill Dorsch, the marshallproject.org

People of the State of Illinois v. Tony Gonzalez, Appellate Court of Illinois, First District,
 Second Division, December 27, 2016, dissenting opinion by Judge Michael B. Hyman

National Registry of Exonerations case summary

Chapter Twenty: Burger, Fries and Ice Cream at Dairy Queen

Center on Wrongful Convictions *First Meal* interview form

California Innocence Project webpage, "DNA and Forensic Analysis," and Horace Roberts
 case summary.

National Registry of Exonerations case summary

Kirk Johnson telephone interview with Cynthia Garza, July 6, 2021

Kirk Johnson telephone interview with Maurice Possley, June 24, 2021

Thomas Fuller and Christine Hauser, "Search for 'Golden State Killer' Leads to Arrest
 of Ex-Cop," *The New York Times*, April 25, 2018, Section A, Pag 1

David Grann, *Killers of the Flower Moon: The Osage Murders and the Birth of the FBI*
 (New York, Penguin Random House, 2018)

Chapter Twenty-one: Golf to Red Lobster

Center on Wrongful Convictions *First Meal* interview form

Max Adler, "Golf Saved my Life," *Golf Digest,* May 20, 2012

Max Adler, "For Valentino, a Wrong Righted," *Golf Digest,* September 19, 2018

Max Adler, "Valentino's Redemption," *Golf Digest*, December 6, 2018

Sam Weinman, "HBO revisits the incredible story of how Golf Digest helped free a man
 from prison," *Golf Digest,* October 29, 2020

Jacey Fortin, "How Golf Digest and College Students Helped Free a Man Wrongly
 Convicted of Murder," *The New York Times*, September 20, 2018, Section A, Page 25

Thomas Rogers, "Art from the Holocaust: The Stories Behind the Images," *BBC.com*,
 February 3, 2016

National Registry of Exonerations case summary

Chapter Twenty-two: T-Bone Phone

Center on Wrongful Convictions *First Meal* interview form

Kirk Johnson telephone interview with Michael Evans, July 21, 2021

National Registry of Exonerations case summary

Chapter Twenty-three: Blind Faith for Juan Rivera

Center on Wrongful Convictions *First Meal* interview form

People of the State of Illinois v. Juan A. Rivera, trial transcript of December 10, 1998,
 Circuit Court of the 19th Judicial Circuit, Lake County Illinois, Judge Christopher A.
 Starck

People of the State of Illinois v. Juan A. Rivera, trial transcript of April 30, 1998, Circuit
 Court of the 19th Judicial Circuit, Lake County Illinois, Judge Christopher A. Starck

People of the State of Illinois v. Juan A. Rivera, trial transcript of November 19, 1993
 Circuit Court of the 19th Judicial Circuit, Lake County Illinois, Judge Christopher A.
 Starck

People of the State of Illinois v. Juan A. Rivera, trial transcript of November 16, 1993
 Circuit Court of the 19th Judicial Circuit, Lake County Illinois, Judge Christopher A.
 Starck

People v. Rivera, 2011 IL App (2d) 091060, Illinois Appellate Court, unanimous three-judge
 opinion

National Registry of Exonerations case summary

Kirk Johnson telephone interview with Cynthia Garza, July 6, 2021

Kirk Johnson telephone interview with Maurice Possley, June 24, 2021

Chapter Twenty-four: Burger, Vegas, and Fiancée

The Associated Press, 2018, (details withheld to protect exoneree's anonymity)

National Registry of Exonerations case summary

Chapter Twenty-five: Blueberries Handfed to Julie Rea

Center on Wrongful Convictions *First Meal* interview form

Kirk Johnson telephone interview with Julie Rea, June 12, 2021

National Registry of Exonerations case summary

The People of the State of Illinois v. Julie Rea Kirkpatrick, n/k/a Julie Harper, court tran-
 script of trial testimony, July 19 2006, Circuit Court for the Second Judicial Circuit,
 Lawrence County, Illinois, Judge Barry L. Vaugahn

The People of the State of Illinois v. Julie Rea Harper, court transcript of closing argument,
 July 25, 2006, Circuit Court for the Second Judicial Circuit, Lawrence County, Illinois,
 Judge Barry L. Vaugahn

The People of the State of Illinois v. Julie L. Rea, court transcript of closing arguments,
 April 8, 2002, Circuit Court for the Second Judicial Circuit, Lawrence County, Illinois,
 Judge Robert Hopkins

The People of the State of Illinois v. Julie L. Rea, court transcript of closing arguments,
 March 1, 2002, Circuit Court for the Second Judicial Circuit, Lawrence County,
 Illinois, Judge Robert Hopkins

Biographies

JULIE GREEN (1961–2021) was a painter and professor at Oregon State University. She spent half of each year painting *The Last Supper* series of one thousand plates that illustrate final meals of US death row inmates. Several experiences informed her decision to focus on racial equality and justice. Leaving for college, the last thing Green's mother said was, "Don't ride a motorcycle without a helmet, and don't marry a Black man." A few years later, cycling in the bike lane along Prospect Park, Green collided with a jaywalker who sued for a million dollars. A law student assisted with representation pro se as the case worked its way through the New York Supreme Court for seven years before being tossed out.

A recipient of the Joan Mitchell Foundation Grant for Painters and Sculptors and the Hallie Ford Foundation Fellowship, Green has had thirty-two exhibitions in the United States and abroad and been featured in publications such as the *New York Times, Rolling Stone*, and *Ceramics* Monthly, in a Whole Foods mini-documentary, and on National Public Radio. Green's work is included in *A World of Art* (Prentice Hall). Upfor Gallery's presentation of *Fashion Plate* and *First Meal* received the Presents Prize at The Armory Show in 2020.

KIRK JOHNSON left the *New York Times* in 2019 after thirty-eight years on the staff—the last fifteen as a national correspondent. For four years, in the mid- to late 1980s, he was the *Times*'s courthouse reporter in Manhattan, covering trials and investigations at a time when violent crime was surging in New York and other cities and when some of the wrongful convictions in this book took place.

In 2001, he was part of a team that won a Pulitzer Prize for national reporting for the multi-part series, "How Race is Lived in America," and in 2013 he met Julie Green while writing about *The Last Supper* series for the *Times*'s art section. That feature led to their collaboration on *First Meal*. An avid long-distance runner, Johnson is the author of a memoir, *To the Edge: A Man, Death Valley and the Mystery of Endurance* (Warner Books, 2001), which recounts his participation in the Badwater Ultramarathon, 150 miles across Death Valley, California. He lives in Seattle.